A LANDSCAPE FOR MODERN SCULPTURE

Storm King Art Center

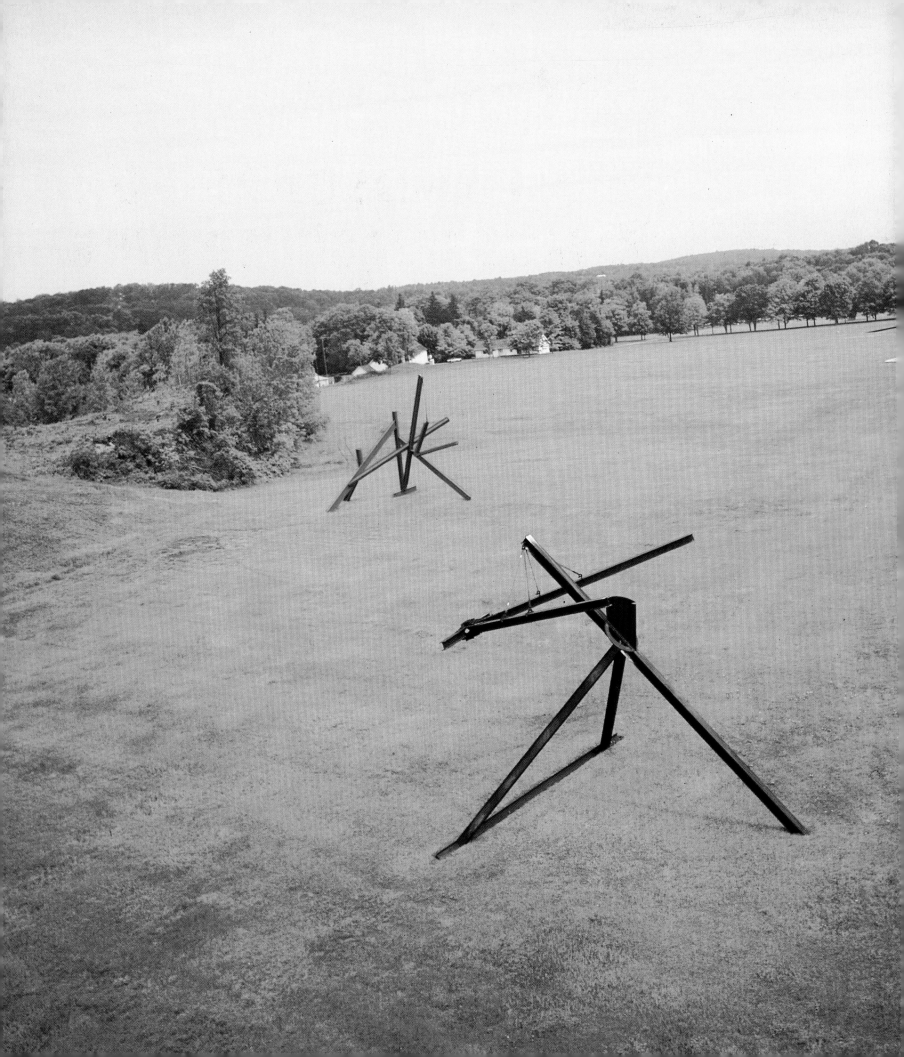

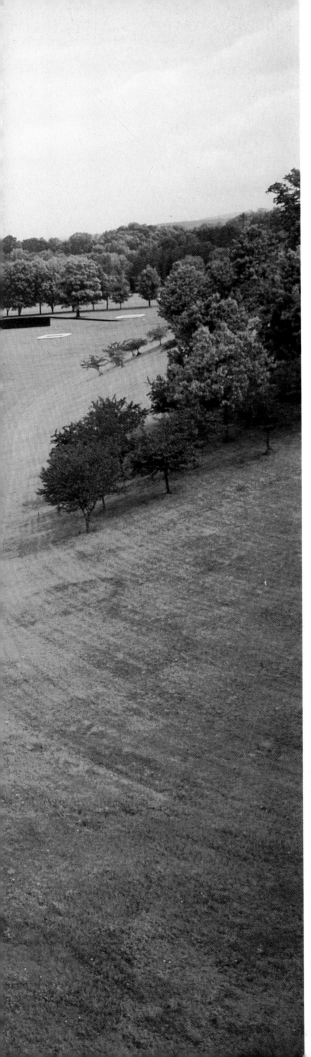

A LANDSCAPE FOR MODERN SCULPTURE

Storm King Art Center

Text by John Beardsley

Photographs by David Finn

Foreword by J. Carter Brown

Introduction by H. Peter Stern

ABBEVILLE PRESS PUBLISHERS

New York London Paris

Acknowledgment: I wish to express my gratitude to the National Endowment for the Arts for their support of my work during the period this manuscript was in preparation. J.B.

Designer: Howard Morris
Editor: Nancy Grubb

Front cover: Aerial view of Storm King Art Center
Back cover: Alexander Calder. *The Arch*, 1975.
 See pages 42–45.
Frontispiece: Mark di Suvero. *Are Years What?*
 (For Marianne Moore), 1967 (left), and *Mon*
 Père, Mon Père, 1973–75. See pages 50–51.

Library of Congress Cataloging-in-Publication Data
Beardsley, John.
 A landscape for modern sculpture.
 Bibliography: p.
 Includes index.
1. Public sculpture—New York (State) 2. Sculpture, Modern—20th century—New York (State)
3. Storm King Art Center. 4. Sculptors—
Biography. I. Finn, David. 1921– . II. Title.
NB230.N7B4 1985 735′.23′0074014731 85-7504
ISBN 0-7892-0246-8 (cloth)
ISBN 0-7892-0247-6 (pbk.)

Second edition, 1996
10 9 8 7 6 5 4 3 2 1

CONTENTS

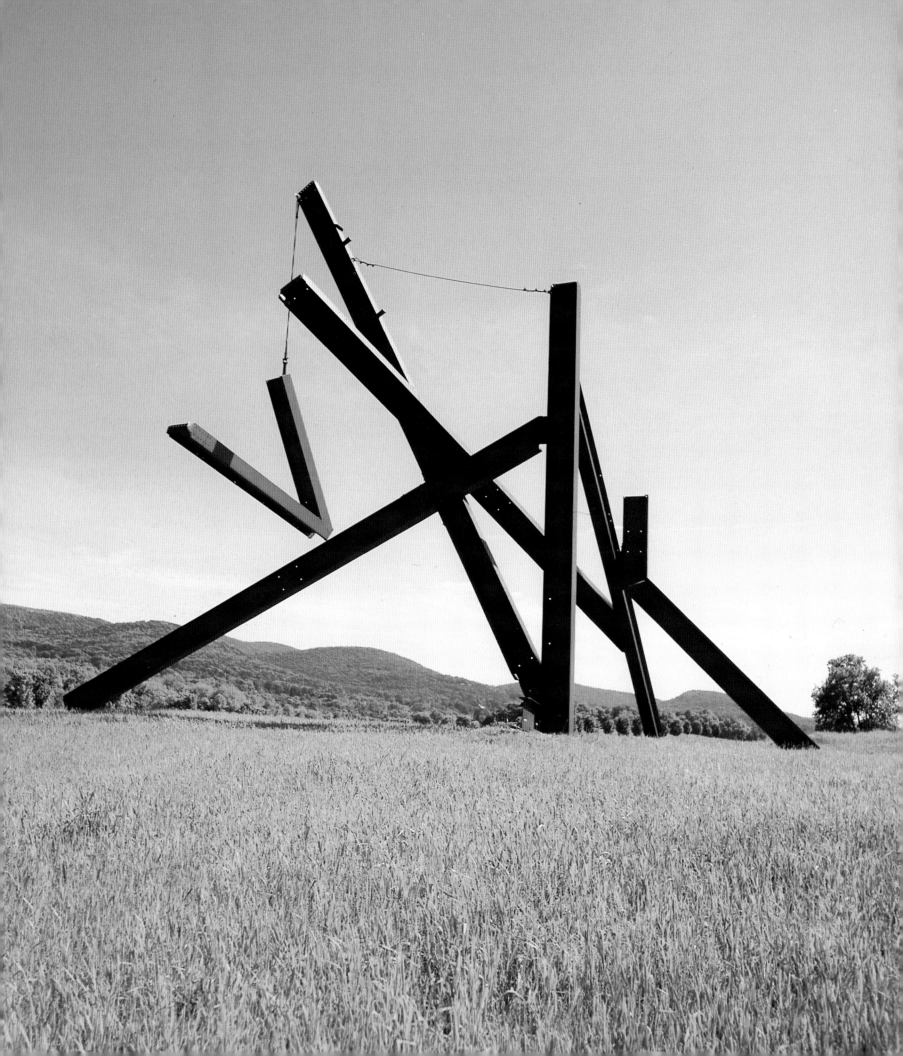

FOREWORD

Storm King Art Center is a remarkable American institution. As a museum devoted to contemporary sculpture, it is outstanding; as an "outdoor" museum it is innovative and imaginative; as an open-air sculpture museum of two hundred acres—most of them given over to the careful display and juxtaposition of large monumental pieces—it provides an extraordinary setting for a fine collection of major works.

There are, of course, small patches of ground here and there throughout the country where outdoor sculpture is on display. The landscape and town squares of America have long been dotted with statues commemorating battles, war heroes, and city fathers. More recently, civic and cultural plazas, shopping centers, and corporate headquarters have become hospitable to the work of more serious sculptors. The East Building of the National Gallery is graced by a fine Henry Moore sculpture at its entrance, and several other museums, like the Modern in New York and the Hirshhorn in Washington, have gardens where a variety of pieces may be seen together. But none of these situations or collections approaches that of Storm King, and thus it is a special pleasure to see Storm King introduced to a larger audience through the pages of this book.

My own association with this remarkable museum has several facets. I came to know its president, H. Peter Stern, through our joint work on the International Fund for Monuments and its activities on behalf of such sites as Venice, Easter Island, and the Coptic churches of Africa. Then, in planning exhibitions for the inauguration of the East Building of the National Gallery, it was natural to look to Storm King for a major loan. The result was the selection, for a site on Constitution Avenue, of Alexander Liberman's *Adam*—a piece that complemented handsomely I. M. Pei's design for the new building. Finally, in the fall of 1977, I was invited to join the board of the Storm King Art Center, and I gladly accepted. I have enjoyed the association immensely ever since. It is as a member of that board that I invite you, in turn, to savor the museum's riches—as revealed in David Finn's splendid photographs.

J. Carter Brown, Director
National Gallery of Art
Washington, D.C.

Mark di Suvero
Are Years What? (For Marianne Moore),
1967
Steel (painted orange), 40′ × 40′ × 30′

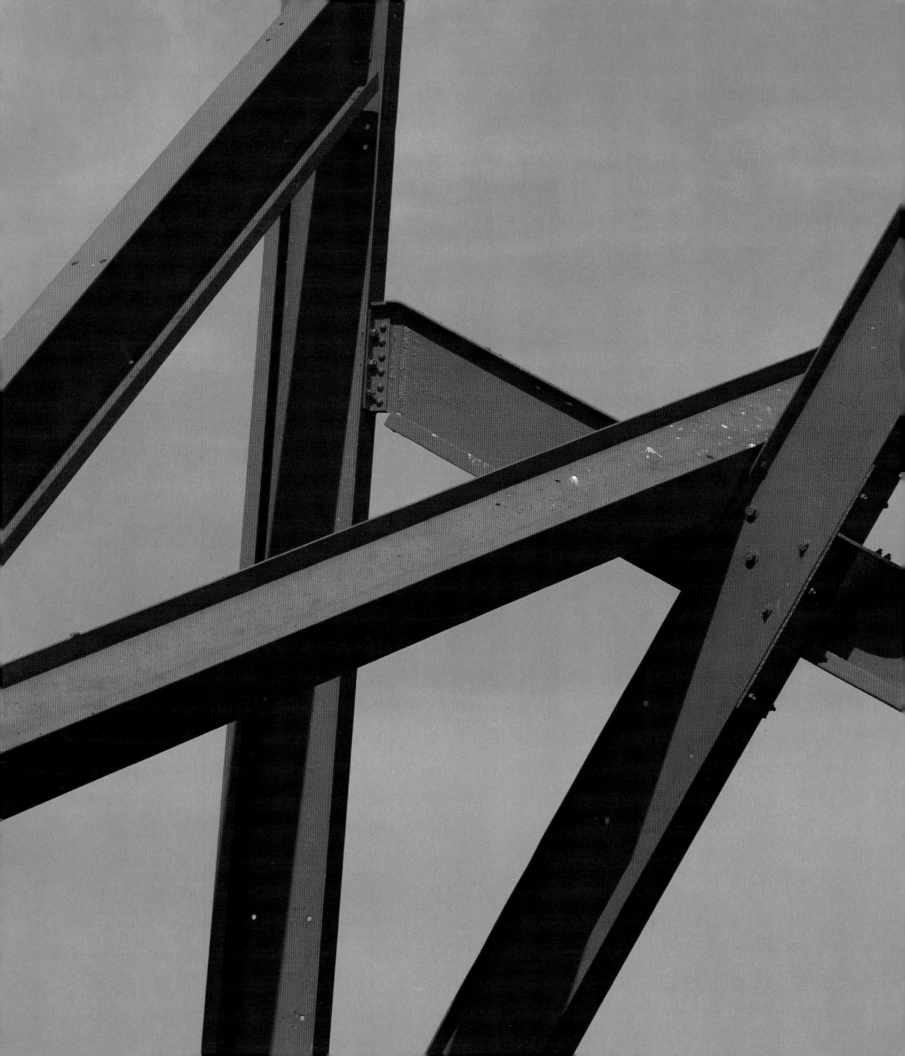

INTRODUCTION

Since the Storm King Art Center was founded twenty-five years ago, some of the finest pieces of modern sculpture have found a home amidst its beautiful rolling hills and woodlands. Located in Mountainville, sixty miles north of New York City, the property is nestled in a lovely valley between Schunnemunk and Storm King mountains. Creating harmonious interaction between this striking Hudson River Valley landscape and the monumental works of art has been one of the Art Center's most exciting challenges.

In its early years, the driving force and much of the support for the Art Center came from Ralph E. Ogden, who died in 1974. Having gradually retired from business in the 1950s, he began collecting art with his wife, Margaret, herself a collector and great-niece of the painter Thomas Hovenden. In 1958 the Ralph E. Ogden Foundation purchased a two-hundred-acre estate, on which Ogden's friend and neighbor Vermont Hatch had built a Normandy-style chateau, and donated it to the newly founded Storm King Art Center. Inspired in part by photographs of the Henry Moore sculptures on Sir William Keswick's sheep farm in Glenkiln, Scotland, Ralph Ogden conceived the idea of developing the Art Center into an open-air museum. While traveling in Austria in 1961 he visited a quarry near the Hungarian border, and after purchasing a number of sculptures done on-site as part of a contest sponsored by the Austrian government, he became engrossed by the challenge of locating them outdoors at Storm King. In 1967 he went to Bolton Landing in upstate New York to see the work of the late David Smith. He decided to buy, and promptly did so in a big way, acquiring all at once thirteen Smith sculptures from the 1950s and '60s. Eight of this group are located outdoors, as at Bolton Landing, with five of the more delicate ones situated inside the museum building. These sculptures constitute a significant nucleus of Smith's work, and their presence at the Art Center has created wide interest in Storm King.

In the last ten years the Art Center has sought to acquire major works by modern masters and to site each of them with a sensitivity to the

Mark di Suvero
Are Years What? (For Marianne Moore), detail

9

sculpture and to the landscape. In 1975 Kenneth Snelson's *Free Ride Home* was purchased and this graceful work of suspended aluminum tubes was placed on the small sculptured hill around which the entrance road curves. Some works were acquired after being on loan to the Art Center. Alexander Liberman's *Iliad*, for example, was purchased following the exhibition of his outdoor works at Storm King in 1977. This bright orange sculpture provides a focal point for visitors entering or leaving the Art Center. In 1981 *Mon Père, Mon Père* and *Mother Peace* were acquired from Mark di Suvero, after they had been on loan for a number of years. Di Suvero placed them in a wide arc, together with two works he had generously loaned. They interact with each other in a dramatic manner whether viewed from the upper area or the fields below. Alexander Calder's *The Arch*, one of his largest and most important works, was purchased in 1982 and placed in the spacious field at the entrance to the Art Center. Louise Nevelson's *City on the High Mountain*, the latest of Storm King's major acquisitions, was installed in 1984. This piece, consisting of black steel plates with one playful moving element, faces the building and can be enjoyed from the entrance as well as from the galleries.

Those who visit Storm King carry away with them a vivid memory of Isamu Noguchi's *Momo Taro*. Noguchi first came to Storm King in the summer of 1977 and immediately expressed his enthusiasm for the place. Within a few days he had conceived a unique new piece consisting of nine massive stones shaped to invite visitors to sit upon and among them. He chose a location on a hill-top to be especially prepared, which overlooked the David Smith area to the south and the foothills of the Catskills to the west. Noguchi's forty-ton sculpture was created at his home on the island of Shikoku in Japan from granite from the neighboring island of Shodoshima and brought to the Art Center in May 1978.

In addition to the works of monumental size, the Art Center has also added to the collection a number of smaller pieces, including works by newer and less well-known artists. With the generous assistance of the National Endowment for the Arts, sculptures were acquired by Carl Andre, Louise Bourgeois, Herbert Ferber, Mary Frank, Richard Friedberg, Charles Ginnever, Lyman Kipp, Robert Murray, Ann Norton, Joel Perlman, Mia Westerlund Roosen, Charles Simonds, Ann Sperry, Richard Stankiewicz, Tal Streeter, George Sugarman, Ernest Trova, and Isaac Witkin. Cynthia Hazen Polsky, vice-president of the Art Center, has assisted us in this effort, contributing one or more works each year since 1977. Her gifts include sculptures by John Duff, Mary Frank, Arthur Gibbons, Jim Huntington, Mel Kendrick, Hubert Long, Louise Nevelson, and Mia Westerlund Roosen.

William A. Rutherford, a remarkably creative landscape architect, has been a key figure in the development of the Art Center. His sensitive work with the terrain has produced graceful hills and slopes that support, balance, and enhance the sculptures resting on them. Rutherford's twenty-five-year association with the Art Center has given continuity and unity to the extensive planting of trees, sculpturing of hills, and planning for

Aerial view of Storm King Art Center

the future development of the land.
Storm King has been fortunate to
have an equally close association with
his wife, Joyce M. Rutherford, an
architect who has subtly changed the
Art Center building from a private
mansion to a public exhibition space,
designing an office from the former
kitchen and garage and a reception
area from the former porte-cochere.
She has also designed houses for the
groundskeepers at the boundaries of
the Art Center property.

David R. Collens, an expert on
twentieth-century outdoor sculpture,
joined the staff in the fall of 1974, be-
came curator in 1975, and has served
as director since 1978. He has orga-
nized the Art Center's annual exhi-
bitions and is well known for the
sensitive installations that reflect his
remarkable eye and his special feeling
for matching site and sculpture. His
passionate devotion to the Center and
to the sculptures has been infectious
to all who have worked with him, and
I have especially enjoyed working
with him in the placement of larger
works.

My love of the area around Moun-
tainville, where I have lived for thirty
years, has found expression in service
to many artistic and educational
projects, which has included partici-
pation on the boards of Vassar Col-
lege, the Hudson Valley Philhar-
monic, Storm King School, Scenic
Hudson, and Mid-Hudson Pattern.
My deepest commitment, however,
has been to the development of the
Storm King Art Center, which I
have served as president since its
inception.

The technical expertise developed
at Storm King for the care of outdoor
sculpture has been appreciated by
many artists who have followed the

museum's suggestions for the mainte-
nance, painting, and safety of their
works. As president of a nearby com-
pany that manufactures metal fas-
teners, I have been able to make
available to the Art Center the tech-
nical advice of some of the company's
engineers. I am grateful in particular
to Lester O. Knaack for his assis-
tance in designing strong but incon-
spicuous concrete bases and for his
advice on the safety of bolts and fas-
teners, rust prevention, and the se-
lection of the most durable paints. In
the early years some of the large
pieces were struck by lightning, and
ingenious research was required to
develop lightning rods that could be
placed out of sight inside the sculp-
tures. We have instituted systematic
inspection, cleaning, and care of the
sculptures all year round. Additional
effort is required in winter, when the
works that are liable to wind dam-
age must be secured and some of the
smaller ones moved inside for protec-
tion, while others require wooden box
shelters.

With the generous help of mu-
seums and other institutions, artists,
and private lenders, the Art Center
has presented a number of major ex-
hibitions during its season, which ex-
tends from the middle of May until
the end of October. In recent years
the policy has been to create exhibi-
tions within the building that relate
to artists represented in the collec-
tion. These have included the David
Smith exhibition in 1976, which en-
compassed sculpture, paintings, and
drawings as well as photographs of
Smith, some of which had been taken
by other artists. The show included
a series of paintings by Dorothy
Dehner of their early years together
at Bolton Landing, entitled *Life on*

the Farm. This series was subsequently purchased by the Art Center and is now on view in the museum. A retrospective in 1977 of paintings, prints, photographs, and sculptures by Alexander Liberman complemented the first outdoor display of his monumental works. The English artist Anthony Caro actively participated in positioning a group of his sculptures on the lawn area behind the building for the 1981 exhibition of his work. In 1983, inspired and assisted by David Finn, we organized a show of Henry Moore's sculpture in coordination with exhibitions of that artist's work in New York City, including the major retrospective at the Metropolitan Museum of Art. A year later, with the generous help of William S. Lieberman, chairman of the museum's Twentieth-Century Art Department, we presented *Twentieth-Century Sculpture: Selections from the Metropolitan Museum of Art*, which included recent acquisitions of modern sculpture as well as a selection of works that had never before been on public display.

In September 1979 the Art Center, with its increased following and national recognition, became a public museum. In order to assist in the implementation of programs, new members were added to our board of directors. J. Carter Brown, director of the National Gallery of Art in Washington, D.C., has been a devoted and creative supporter. Cynthia Hazen Polsky—an artist, collector, and trustee of the Metropolitan Museum of Art—joined the board in 1977 and became vice-president in 1979. She has worked with the board on every phase of the Art Center's development. Howard W. Lipman, chairman of the board of

the Whitney Museum of American Art and a major collector in several fields, including modern art, has provided guidance on acquisitions. Leslie A. Jacobson, now of counsel and until recently chairman of the law firm Fried, Frank, Harris, Shriver and Jacobson, has been generous with legal and practical advice. Eugene L. Cohan, vice-president and treasurer, has volunteered many hours keeping the financial affairs in order, and Secretary Spencer L. Koslan has ably handled our regulatory, real estate, and legal questions. Lowell Wadmond,

until recently senior partner of White & Case and for many years chairman of the Metropolitan Opera, has been a staunch supporter.

David Finn, a renowned photographer of sculpture, first visited Storm King in 1977. His enthusiastic response to the Art Center resulted in his generous offer to create a photographic book about it. Finn discussed the project with the late Harry Abrams, whose own enthusiasm led to the publication of *Sculpture at Storm King* by Abbeville Press in 1980. David Finn's photographs in

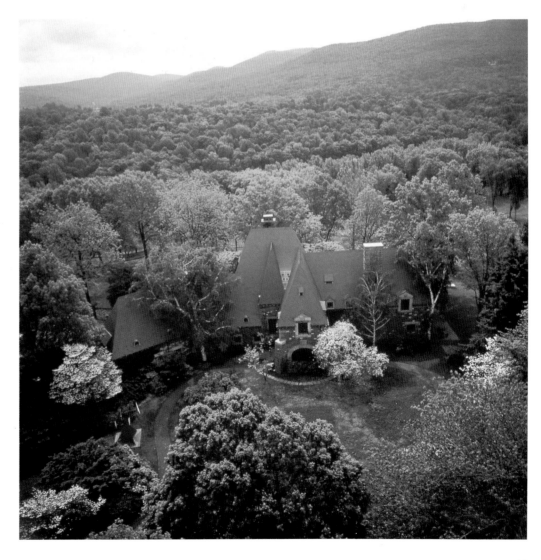

that book—as in this one—magically capture the essence of the works of art and their relation to the land. He has taken pictures in the dogwood season of spring and in the golden time of fall, and, for the first time, he has taken panoramic photographs of the Art Center from a helicopter, which literally add a new perspective to this book.

To promote broader public partici-pation Storm King inaugurated the Friends of the Storm King Art Center in 1978. Special credit goes to Georgene Zlock, who has assisted in administering our Friends program. We are grateful for the warm support we have received from many individu-als, corporations, and foundations, as well as the National Endowment for the Arts and the New York State Council on the Arts. This support, as well as the public response to the Art Center and its unique programs, is heartening. We look forward to the further realization of the Art Cen-ter's potential, showing works of the twentieth century—particularly monumental sculpture—in our unique setting.

H. Peter Stern
President

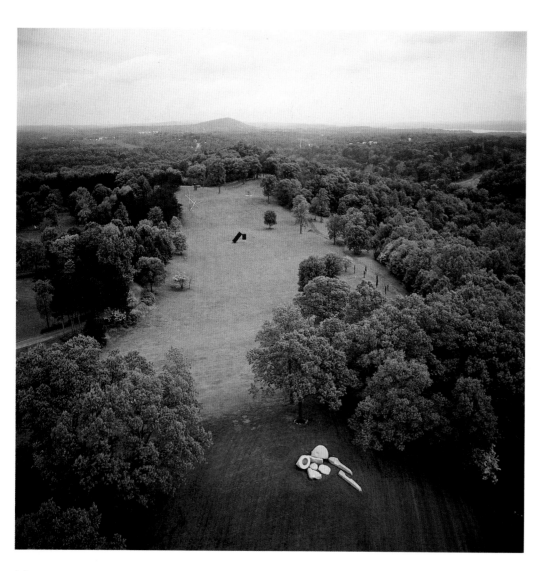

Aerial view with Isamu Noguchi's *Momo Taro* in foreground

A LANDSCAPE FOR MODERN SCULPTURE

Storm King Art Center

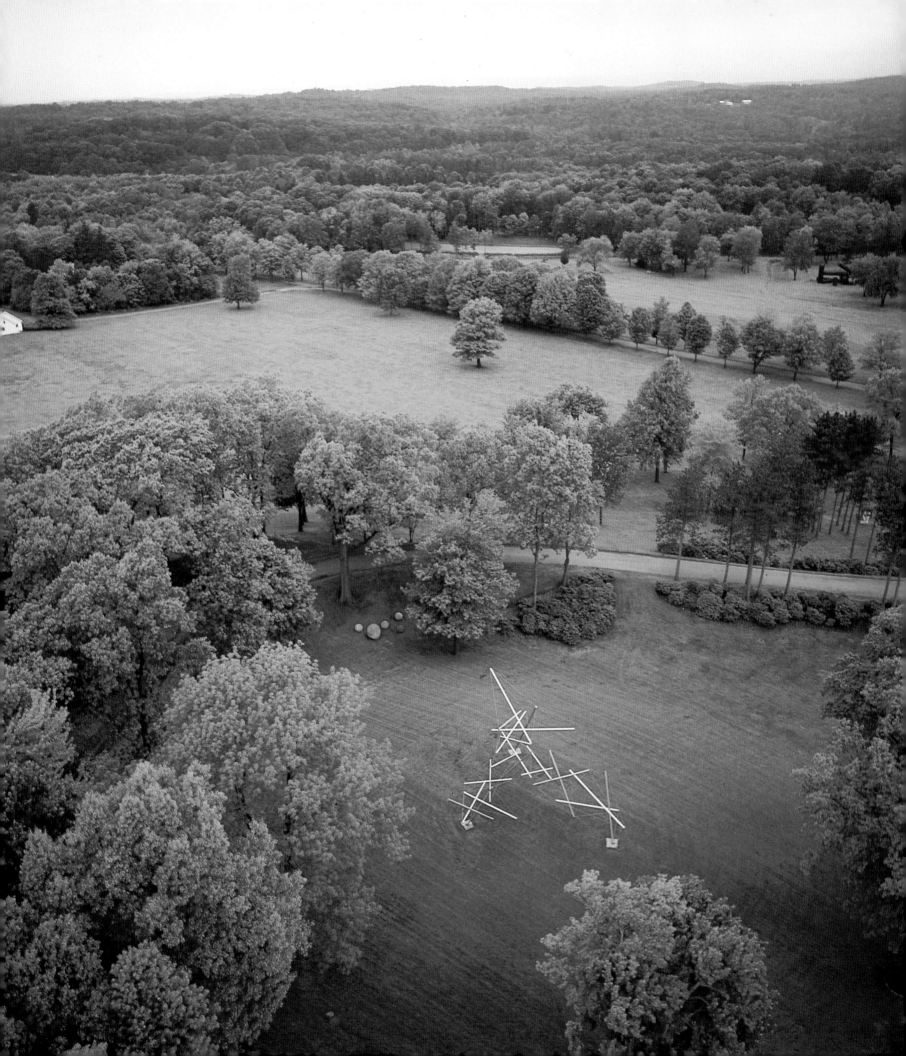

A LANDSCAPE FOR MODERN SCULPTURE

BY JOHN BEARDSLEY

Storm King. Twenty-five years ago, an art institution with initially modest ambitions was born into this evocative name. In the years since, the Storm King Art Center has come to embody all the drama and majesty of its mountain namesake. It has evolved into one of the few places in the world where one can begin to measure the exalted aspirations and achievements of postwar sculpture.

The Storm King Art Center lies in the highlands to the west of the Hudson River, about sixty miles north of New York City in Mountainville, New York. It is a two-hundred-acre estate transformed into a sculpture park—a place where landscape and sculpture are brought together in the most deliberate manner and to the considerable enhancement of both. Although the modern sculpture park is a relatively recent phenomenon, it is not without precedent. The ancient monuments at Abu Simbel and Giza in Egypt, the sculpture in the Renaissance gardens of Bomarzo and the Villa d'Este in Italy, and that in the Tuileries and the park at Versailles in France constitute a distinguished—albeit partial—pedigree for the placement of sculpture in the landscape.[1] Yet never before has sculpture so required a place of its own.

Modern sculpture has been rendered homeless. Despite its ever-growing popularity, it is no longer appropriate in traditional contexts. In large measure, this is the outcome of modernism's deliberate goals. New materials were called upon to replace the old: first iron, then steel, then aluminum, fiberglass, neon, and even lasers were endorsed by sculptors as the proper media for our highly technological era, supplanting the venerated wood, stone, and bronze. Even more importantly, sculptors began stripping away from their art many of its conventional purposes: the depiction of recognizable images, especially the human figure; the commemoration of the past; the embellishment of architecture; and the symbolic expression of lofty ideals. Modern sculpture was expected to create its own purpose instead, to succeed or fail on its own merits as a form in space. It was to carry no content other than its own; its shape and proportions were to be self-generated. No longer the bearer of extrinsic meaning, it would stand instead as the revelation of

Aerial view with Kenneth Snelson's *Free Ride Home* in foreground

intrinsic significance.

In the post–World War II era, this self-justifying and overwhelmingly abstract sculpture could claim qualitative and quantitative dominance.[2] Taken into the neutral spaces of museums and galleries, it looked very good indeed: confident, innovative, and in every sense modern. It seemed to be tacitly understood that because it carried its own meaning this sculpture demanded a place unto itself. The best of the modern sculptors made a virtue of this. Brancusi created a whole environment of sculpture in his studio, which was willed, intact, to the French people upon his death and which stands to this day in front of the Centre Pompidou in Paris. David Smith created something similar outdoors at his home in upstate New York, which, alas, did not long survive him. But modern sculpture soon became the victim of its own ambitions. With the technical capabilities and the will there for sculptors to work at an unprecedented scale, by the 1960s much of their work had outgrown the hospitable confines of the indoor art space.

Whither this new sculpture, monumental in size and disquietingly unfamiliar in appearance? Those museums fortunate enough to possess exterior space could accommodate a small number outside their doors, as at the Louisiana Museum in Humlebaek, Denmark, or the Fondation Maeght in Vence, France. Some museums could create distinct sculpture gardens, such as the one at the Museum of Modern Art in New York, which opened in 1939, and the Hirshhorn Museum and Sculpture Garden in Washington, D.C., which opened in 1974. But even the best of these spaces turned out to be cramped when compared to the size of contemporary sculpture and the quantities of it that were being produced. For most of those sculptures that were larger than life-size, a truly appropriate home had yet to be found.

Recently, through a variety of government mechanisms, numerous monumental sculptures have made their way into public spaces. But this solution has not been entirely felicitous. Many of these sculptures have been crowded into urban situations where they are visually overwhelmed. Others have been called upon to redeem mediocre architecture, an unreasonable expectation for even the finest of sculptures. Yet even when sculpture and architecture are at their best, there often remains an awkward disjunction between the overwhelmingly personal nature of the artistic statement and the traditional expectation that public art would share some meaning with its audience. Given these many problems confronting recent monumental sculpture, it is small wonder that much of it, if fabricated, remains in storage and that many more ideas fail to develop beyond a proposal or maquette.

It is perhaps in response to these problems that several modern sculpture parks have made their appearance in Europe, the United States, and Japan over the past several decades.[3] At times these parks are found in association with museums, as in the case of the Billy Rose Sculpture Garden at the Israel Museum in Jerusalem, designed by Isamu Noguchi in the 1960s, or the Kröller-Müller Museum in Otterlo, the Netherlands. But in both these instances the scale and splendor of the landscape setting, as well as the sheer quantity of sculptures, make these parks nearly autonomous from the indoor collections. Indeed, although the Kröller-Müller also houses a remarkable collection of paintings, it is for the outdoor works that it is most widely celebrated.

The Storm King Art Center joined the growing number of sculpture parks in 1960; as such it postdates many of the European parks and gardens, while predating those of Japan. In many ways, it is unique, distinguished by its combination of great size and dramatic setting. Its two hundred acres of meadow and woodland vastly out-scale the approximately twenty-seven acres of the Kröller-Müller, for example, or the five acres of the Billy Rose. And it has few rivals in terms of the wildness and majesty of the surrounding terrain. European parks, again such as the Kröller-Müller or the Open-Air Museum of Sculpture in Middelheim, Belgium—the latter located in a botanical garden—have a domesticated, intimate feeling; Storm King has the look of a place carved out of a forest. The grandeur of its mountainous setting is rivaled only by two outdoor collections in Japan; the Hakone Open-Air Museum and the Utsukushi-Ga-Hara Open-Air Museum. Storm King is also distinguished, certainly among American collections, for its singleness of purpose, which is to do what no other institution could do in depth: to collect the finest examples of post–World War II sculpture, especially those intended for the outdoors that are too large for other institutions, and to display them to their best possible advantage. They have been hugely successful: in few other places does sculpture look so at home.

Precisely why Storm King is so hospitable to modern sculpture is my

ultimate subject. It results from the
happy conjunction of two principal
elements—sculpture and landscape—
which I will first look at individually.
A brief history of the Art Center will
lead to an examination of the particu-
lar focus and strengths of the Storm
King collection. A history of the land-
scape will follow, tracing its evolution
from country estate to sculpture
park. Then I will return to the partic-
ular puzzle of this place: how sculp-
ture and landscape, ostensibly so
different, are held in such satisfying
equilibrium at the Storm King Art
Center.

Henry Moore
Reclining Connected Forms, 1969
Bronze (green patina), 38″ × 87¾″ × 52″

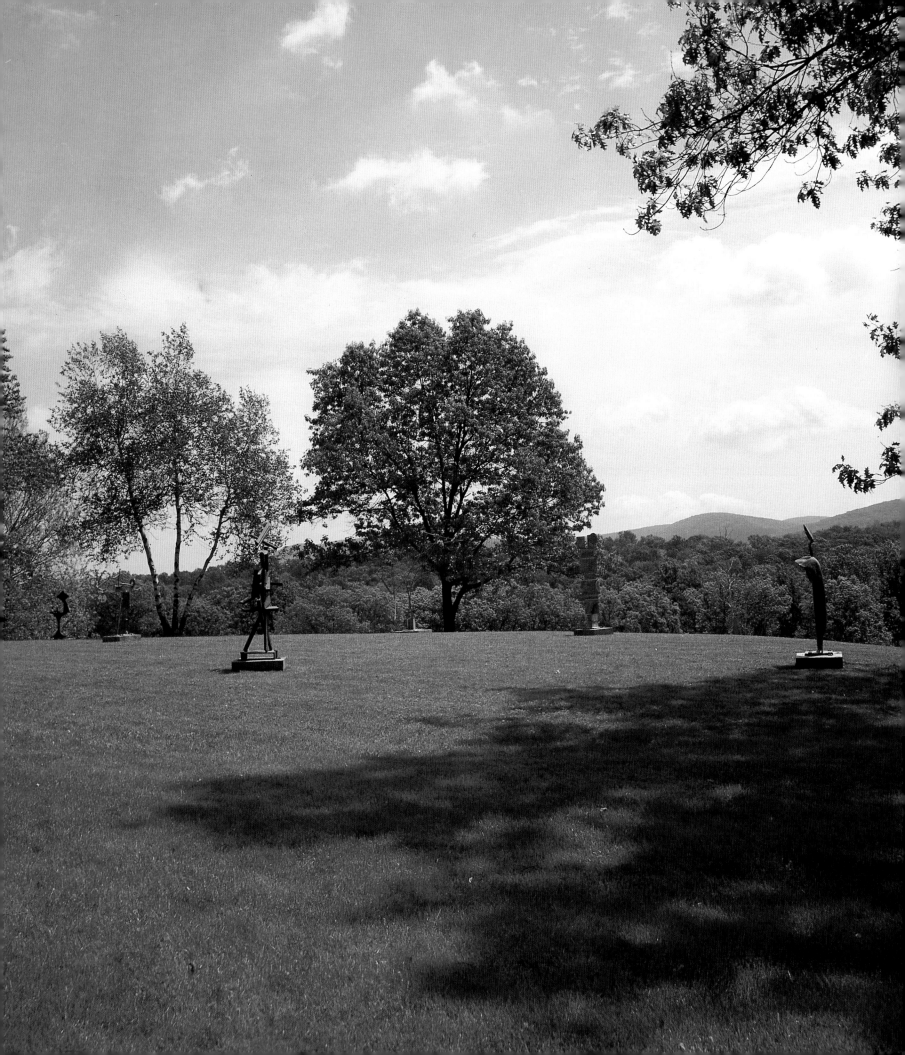

THE COLLECTION

When the Storm King Art Center was chartered, it was to be a regional museum with a local constituency and a flavor determined by its Hudson Valley location. As Ralph Ogden, a founder and major supporter of the Art Center during the early years, told a writer from *Art in America* in 1969, "I look upon this museum as a 'county museum,' an adjunct to the education of the big city museums."[4] The acquisitions and exhibitions of the Art Center's early years were consistent with this notion of a "county museum." The collection included paintings, prints, and drawings, with an emphasis on the Hudson River School but also encompassing work from the old masters to the moderns, from the Europeans to the Americans and the Japanese. The exhibition program was similarly eclectic, but again featured the Hudson Valley. An exhibition entitled *Famous People and Famous Events in American History* in the summer of 1961 was followed by shows of Jerome Meyers, Joseph Stella, and John Sloan in the summer of 1963. The same year the Art Center presented a widely praised exhibition of works painted by Winslow Homer during the summer he spent in Mountainville in 1878. These shows were followed by *Animals in Art* in 1964 and, in 1966, old master and contemporary Japanese prints as well as an exhibition of Hudson River prints.

Yet during these same years the foundations were being laid for an institution of an entirely different order: an institution with a different and more focused collection, with a broader constituency, and with aspirations well beyond those of a "county museum." The first indication of this future expansion came in 1961, when Ralph Ogden visited a stone quarry near the Hungarian border in Austria that was being used as an outdoor studio by several sculptors. Ogden acquired three works during that visit: biomorphic abstractions by Karl Pfann, Josef Pillhofer, and Erich Thorn. Peter Stern, another of the Art Center's founders and its president, recalls that it was the excitement of seeing these works in the Storm King landscape that inspired them to further acquisitions of outdoor sculpture. As Stern recalls, "These sculptures looked great when

Sculptures by David Smith

we got them here. We realized that this is what we ought to do."[5] To be sure, Ogden had visited the sculpture park at the Kröller-Müller and had seen with enthusiasm photographs of Henry Moore sculptures in the landscape at Sir William Keswick's sheep farm in Glenkiln, Scotland. But, Stern insists, "the inspiration came from here, from the Mountainville landscape."

Two years later Ogden was back in Austria, where Pillhofer gave him an introduction to Fritz Wotruba. Ogden recalled in 1969, "I got inter-ested in Wotruba because Pillhofer had been his student. Then, when I saw the master's work—and liked it so much—I knew I was going up."[6] Ogden returned with Wotruba's *Man Walking* (1952), his first major acquisition. He was developing simultaneously his enthusiasm for outdoor sculpture and his confidence as a collector.

The following few years saw several other sculpture acquisitions, principally of work by artists born and trained in Europe: Emilio Greco, Eloul Kosso, Sorel Etrog, and Max Bill. There is a striking range in these works, from the mannered representationalism of Greco's *The Tall Bather I* (1956) to the robust expressionism of Etrog's *Etude de Mouvement* (1965) and the crystalline simplicity of Bill's *Unit of Three Elements* (1965). It is as if Ogden and his colleagues were setting out to test the adaptability of the Storm King landscape and the viability of their evolving plans for it. They took stock of their building, their distance from New York, and the limitations inherent in being a regional museum, which Stern describes as "charming, but not a major mission." They realized they had the space to do what could not be done in the city, and the right landscape for it. They were on the brink of their new and major mission.

This mission was confirmed in 1967 with the acquisition of thirteen sculptures by David Smith. The *New York Times* announced the purchase as "a coup that a major art museum might crow over" and "the biggest batch of Smiths ever sold to a single purchaser."[7] Although the wisdom of this acquisition is now unquestionable, with Smith's reputation secure as one of the greatest modern sculptors, it

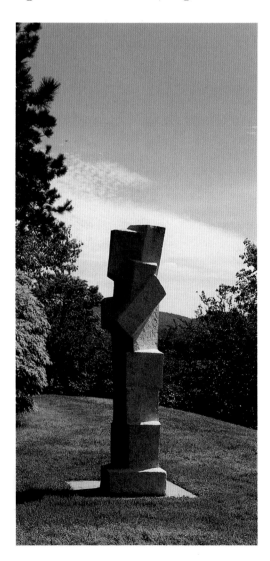

was less so at the time. Few museum exhibitions had been devoted to Smith during his lifetime, with the principal one at the Museum of Modern Art in 1957, before his extraordinarily prolific final years. The problem of his reputation was compounded by a penchant for hoarding his work: he wanted his sculptures around him and set such high prices for them that few would sell. Of the over 190 sculptures Smith made from 1960 on, only twenty-two were sold and a few given away during his lifetime.[8] When he died in 1965, some eighty of these sculptures were arrayed in two fields before his house and studio in rural Bolton Landing, near Lake George in upstate New York.

On the advice of friends, Ogden visited Bolton Landing about a year after the artist's death. With disarming candor, he told *Art in America* in 1969, "I'd been looking for something to sort of 'make' the Art Center, and when I saw the effect of Bolton Landing, I thought then, a bit like a square businessman would, what an amazing opportunity! Why not get more than one?"[9] Stern had earlier made a similar statement to the *Times* for their

report on the purchase: "We wouldn't in the least mind being known as one of the places to see Smith's work. Obviously, we appreciate him, and we feel as a small museum we're better off collecting the work of an artist in depth than trying to acquire a smattering of everything." In addition, Stern noted that Smith was long a "New York state boy."[10]

This last remark may sound facetious, but it is only partly so. Stern remembers that Ogden had admired the way the sculptures fit into the Bolton Landing landscape and recognized the affinities between Bolton Landing and Storm King. If there are other collections of Smith's art more extensive or diverse than that of Storm King—both the Museum of Modern Art and the Hirshhorn Museum and Sculpture Garden, for example, have significant holdings of his work—then the Art Center is the only place where one can experience Smith's art as Smith himself did, for what he described as his "sculpture farm" has long since been dispersed. In a small way, Storm King preserves Smith's legacy. But the debt is reciprocal, for one can hardly overestimate the impact of Bolton Landing on Storm King. More than Glenkiln or the Kröller-Müller, it was the true predecessor to the Storm King Art Center.

LEFT TO RIGHT:
Joseph Pillhofer
Untitled, c. 1950–60
Stone, 91″ × 21″ × 16″

Emilio Greco
The Tall Bather I, 1956
Bronze, 84½″ (including 1½″ base) × 18¼″ × 28″

Fritz Wotruba
Man Walking, 1952
Bronze, 58½″ (including 1″ base) × 19″ × 24½″; base (cast as part of the piece): 1″ × 17¾″ × 24¼″

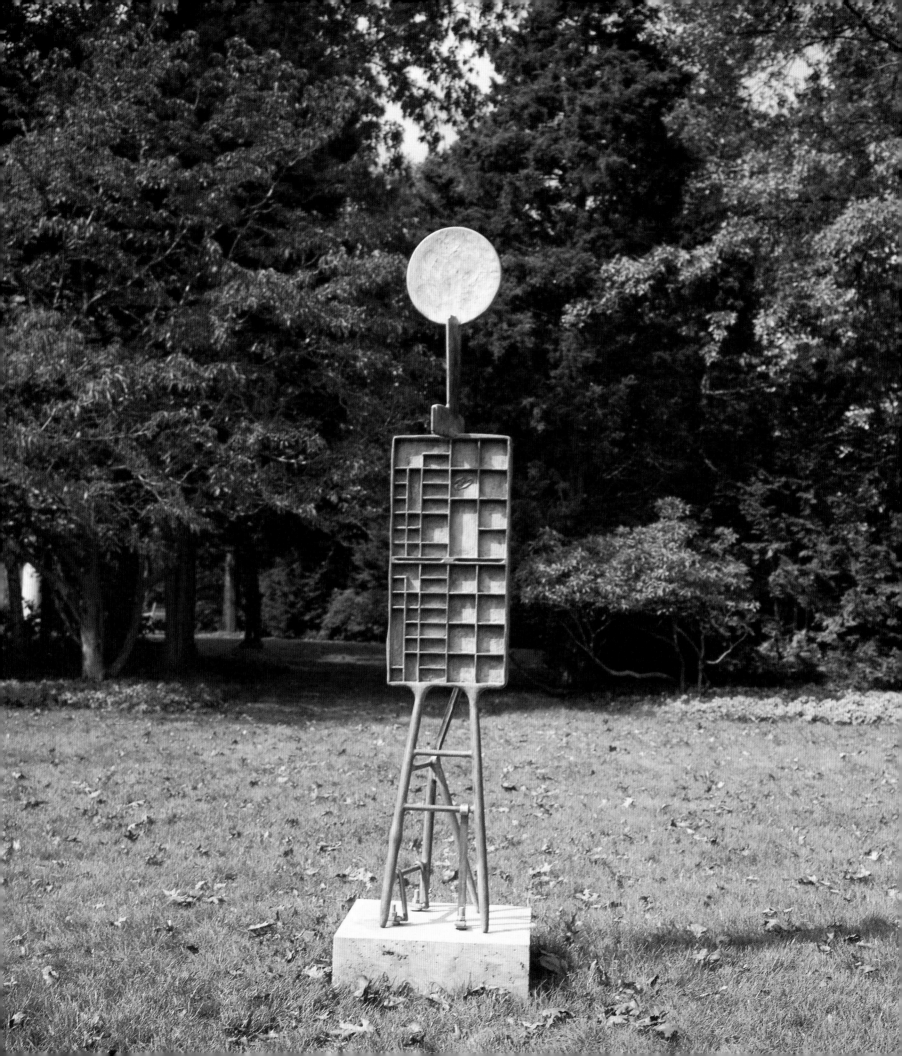

David Smith's sculpture was notably different from what the Art Center had been collecting. The early acquisitions were predominantly European and traditional in appearance—cut from stone or cast in bronze—but the Smiths were American and incontrovertibly modern. In part, this last reflects his choice of material and technique. Smith, born in Indiana in 1906, had worked as a welder in a Studebaker factory in South Bend in 1925. Five years later, having moved to New York and studied at the Art Students League, he saw illustrations in the periodical *Cahiers d'art* of welded-metal sculpture by Picasso and Julio González. The latter, a Spaniard like his friend Picasso, had worked as a welder in a Renault factory in France during World War I. By the late 1920s he had transformed this experience into a new technique for making sculpture: directly welding together metal components rather than carving or casting. This allowed for a much more open, linear, and spatially complex sculpture. González shared this discovery with Picasso; indeed, it was González who actually welded together one of Picasso's first constructions in metal wire in 1930. Smith, too, seized upon this new technique. "Since I had worked in factories and made parts of automobiles and had worked on telephone lines," Smith later recalled, "I saw a chance to make sculpture in a tradition I was already rooted in."[11] By 1934 Smith had acquired a welding outfit and an oxyacetylene torch and had rented work space in a machine shop known as Terminal Iron Works on Atlantic Avenue in Brooklyn.

The genesis of Smith's art in the materials and techniques of the fac-tory accounts for only part of its newness. Smith was heir to all aspects of European modernism and combined them in his own unpredictable and free-spirited way. From Cubism, via Constructivism, came an approach to form that admitted the fragmented and the partial and stressed line and planar surface over volume and depth. "Cubism," Smith asserted, "essentially a sculptural concept originated by painters, did far more for sculpture than any other influence. . . .

David Smith
Sitting Printer, 1954, and detail
Bronze (green patina), 87¼" × 15¾" × 16"

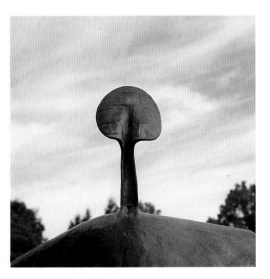

Cubism freed sculpture from monolithic and volumetric form as Impressionism freed painting from chiaroscuro. The poetic vision in sculpture is fully as free as in painting."[12] From Surrealism came the precedent for incorporating the whimsical, the fantastic, and the irrational, especially those thoughts and feelings arising from the subconscious or unconscious mind and appearing in dreams or visions. And from the tradition of German Expressionism came an enthusiasm for animated forms and exuberant gestures. Yet this stylistic pedigree hardly accounts for Smith's achievement: he would have been little more than a pasticheur had he simply mimicked the forms of his European predecessors. Instead, Smith took what he wanted from each of them and took them all farther. The Cubist collage in his hands became monumental sculpture, heroic in figurative if not in literal scale. The sculpture of his later years especially was more nearly abstract than anything produced in Europe before him, with the exception of work by Constructivists such as Naum Gabo and Antoine Pevsner. But unlike the Constructivists—and this is a critical distinction—Smith eliminated the core or spine from many of his works, freeing them from the last convention of traditional sculpture and allowing them an elusive, even illogical, form that defies immediate understanding.[13] Though we can assume we know these sculptures when looking at them from a single viewpoint, rarely is this so: their structural complexity makes them appear to be virtually different sculptures from different perspectives.

Although they were all executed

between 1954 and 1964, the Smith sculptures in the Storm King collection well represent the range of his achievement, as well as his recurring themes. One of these is the totem, an anthropomorphic image with frequently Surrealistic overtones. *Sitting Printer* (1954) and *Personage of May* (1957) are two such sculptures. In some ways, these are the most conventional of the Smiths in the Storm King collection. Both are cast in bronze from assemblages of found objects, in the manner of many Surrealist works. In addition, both retain the central core of traditional monoliths, though they are composed of planar rather than volumetric forms. The head and neck of *Personage of May* are cast from a shovel; on the outside, two circles that resemble rivets provide a pair of spectral eyes, while on the inside, two arcs of metal resemble brows. About *Sitting Printer*, Smith recollected in 1965: "A few years ago, when I taught at Indiana University, I had to take another sculptor's studio. . . . It was a hell of a mess when I walked in there, and I didn't know what to do. . . . The first thing I did was to take those things and make a sculpture out of them."[14] A type box from a print shop, the top and legs of a broken stool, and the center piece from the back of a classroom chair are the attributes of this character.

David Smith
Personage of May, 1957, and detail
Bronze (green patina), 71⅝″ × 32″ × 19″

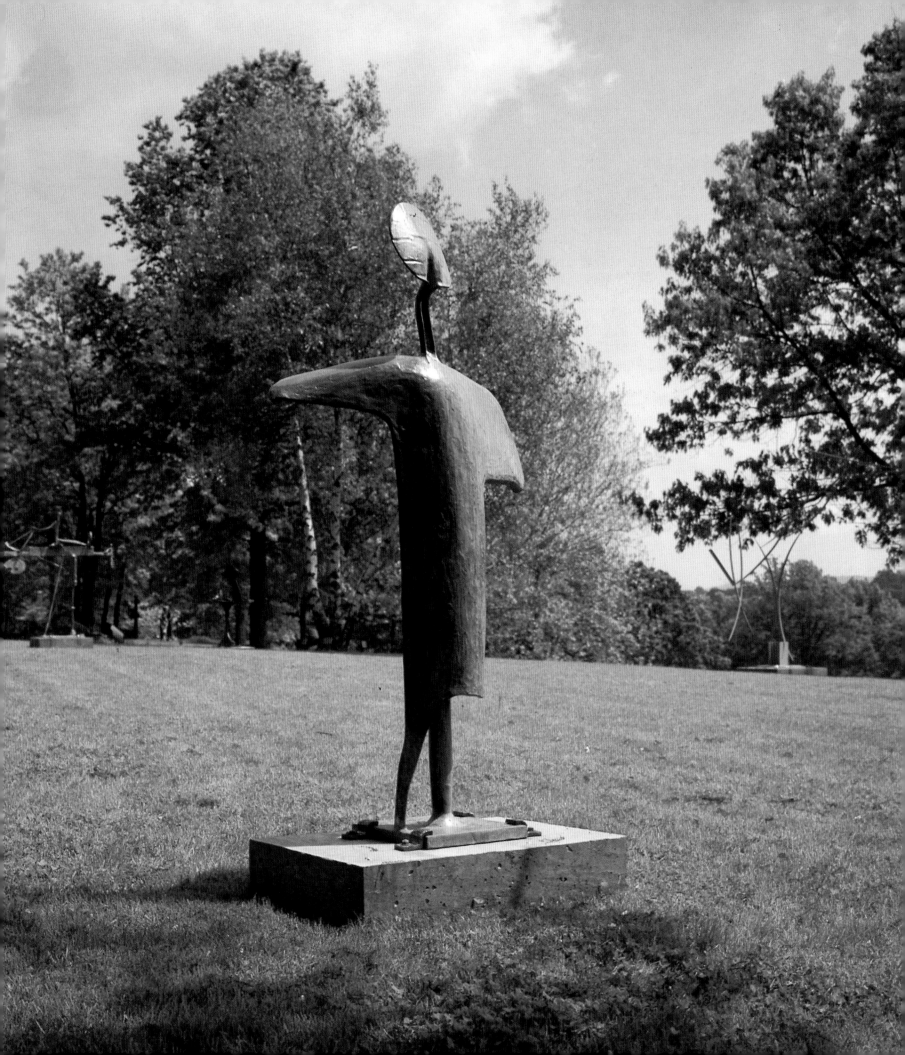

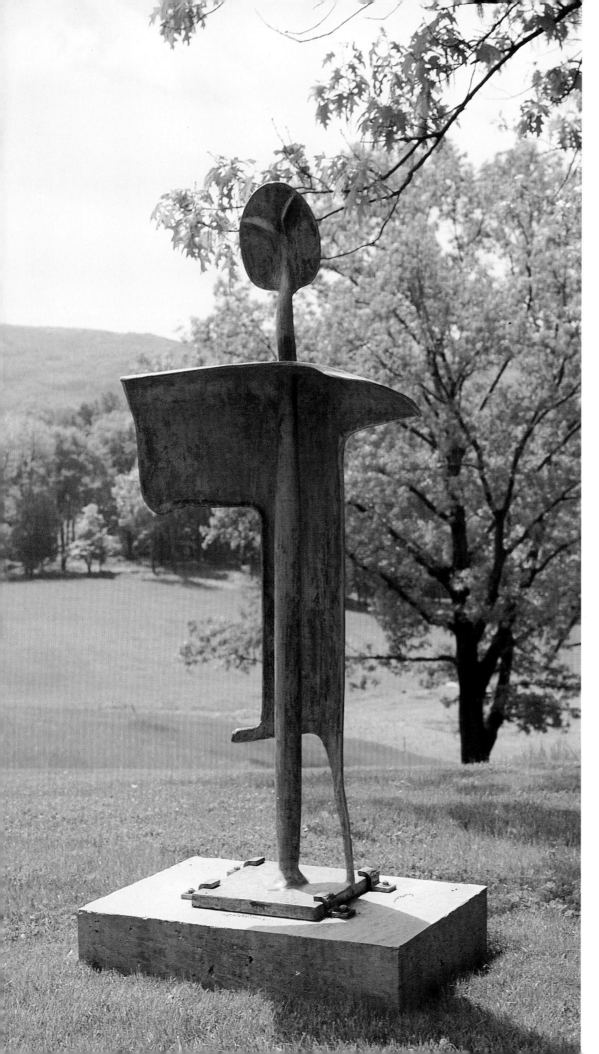

LEFT TO RIGHT:
David Smith
Personage of May and detail

The Iron Woman, 1954–56, and detail
Steel, 88″ × 14½″ × 16″

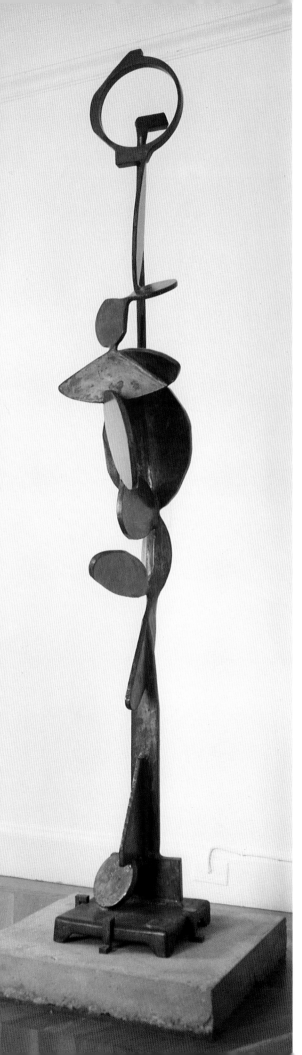

The *Iron Woman* (1954–56) likewise has the imposing qualities of the totem, the object at once desired and forbidden. But this one is assembled directly from cut and welded steel elements. An open circle forms the head, while a confusing array of disks suggests breasts, pelvis, hips, and thighs. At the base of the sculpture, a final circle resembles the delicately poised foot of a figure at rest in the contrapposto position.

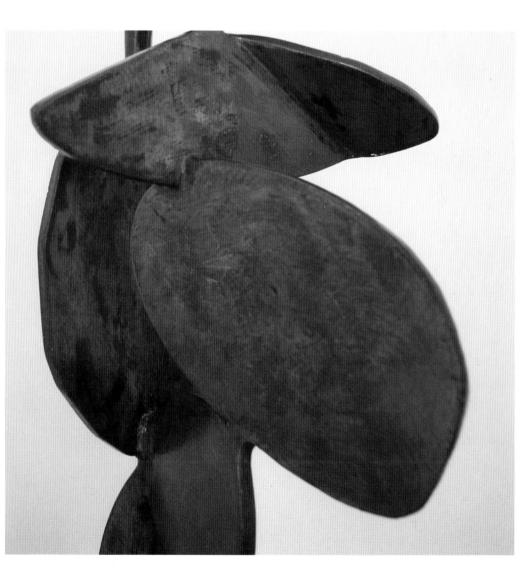

The totem theme reached an apogee with the Tanktotem series, of which number seven (1960) is in the Storm King collection. This series, numbering ten works, was begun in 1952 and terminated in 1960; it reflects Smith's tendency to produce groups of related works. The Tanktotems were named for a prefabricated element that appears in each of them: the curved top of commercially made boiler tanks. In the case of *Tanktotem VII*, made of welded steel, the totemic image is combined with an instance of visual punning or subterfuge. Smith painted this work, as he did many of his sculptures. It is a cobalt blue, with patches of white: one of these makes the tank top appear to be perforated, while another visually transforms a broad steel plate into a narrow vertical shaft.

Portrait of a Lady Painter (1957) is likewise somewhat figurative. It lacks the insistent verticality and monumentality of the totemic sculptures, however, having more the intimate, domesticated feeling of a still life. A figurative sense is provided by the slender bars that suggest arms and legs; but the dominant image is a flat surface, a table top, perhaps, on which are grouped the attributes of the lady painter: one that is certainly a palette, others that resemble a comb and an eye.

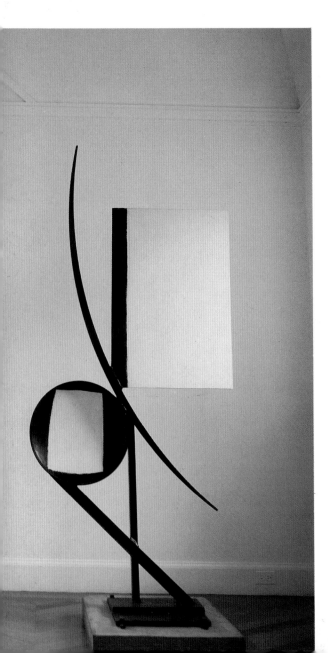

David Smith
Tanktotem VII, 1960
Steel (painted dark blue and white),
84″ × 36½″ × 14¼″

RIGHT:
Portrait of a Lady Painter, 1957,
and details
Bronze (green patina), 63⅝″ ×
59¾″ × 12½″

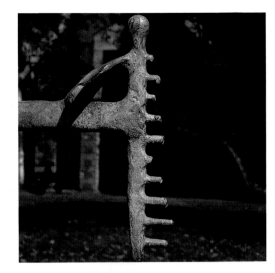

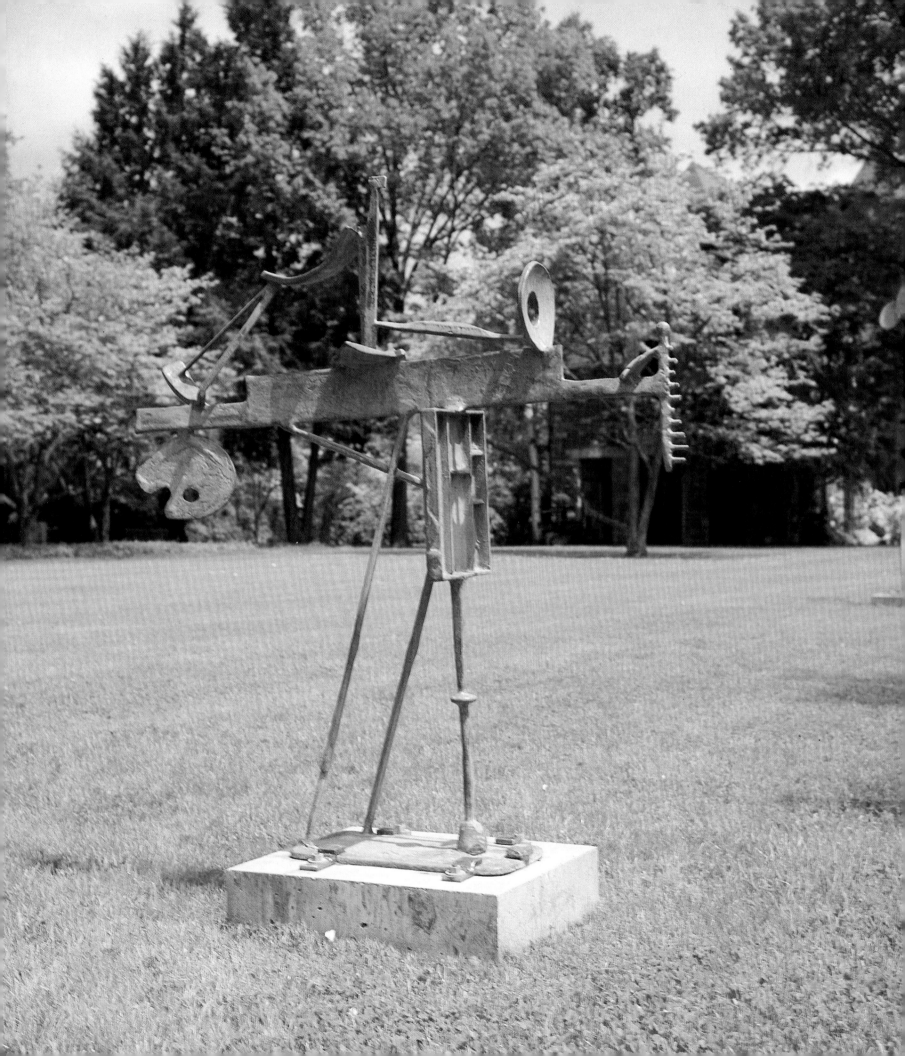

Like the totem, the still life was a theme to which Smith turned again and again. It found expression in two welded stainless steel works in the Storm King collection: *XI Books III Apples* (1959) and *Three Ovals Soar* (1960). These are not merely still-life sculptures: the three ovals, for example, are a minor element compared to the curving vectors on which they rest; both sculptures exploit as well the light-reflecting and form-diffusing character of burnished stainless steel.

David Smith
XI Books III Apples, 1959, and detail
Stainless steel, 94″ × 31¼″ × 13¼″

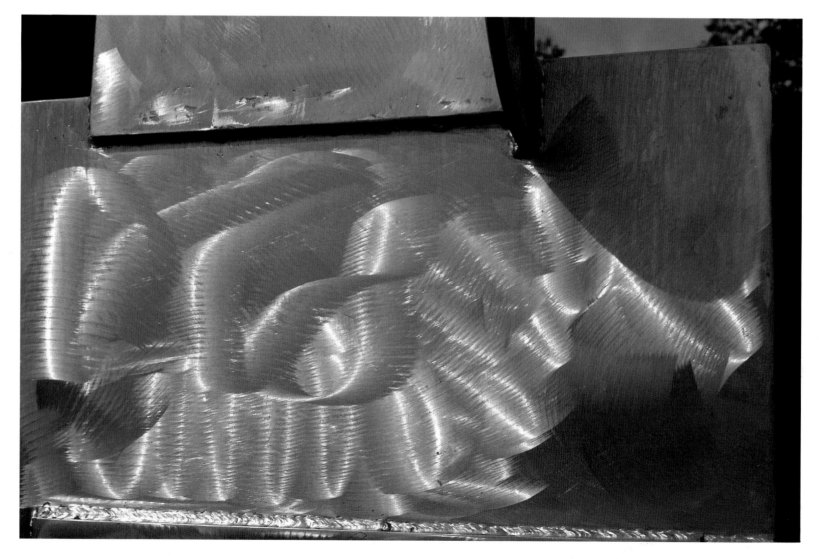

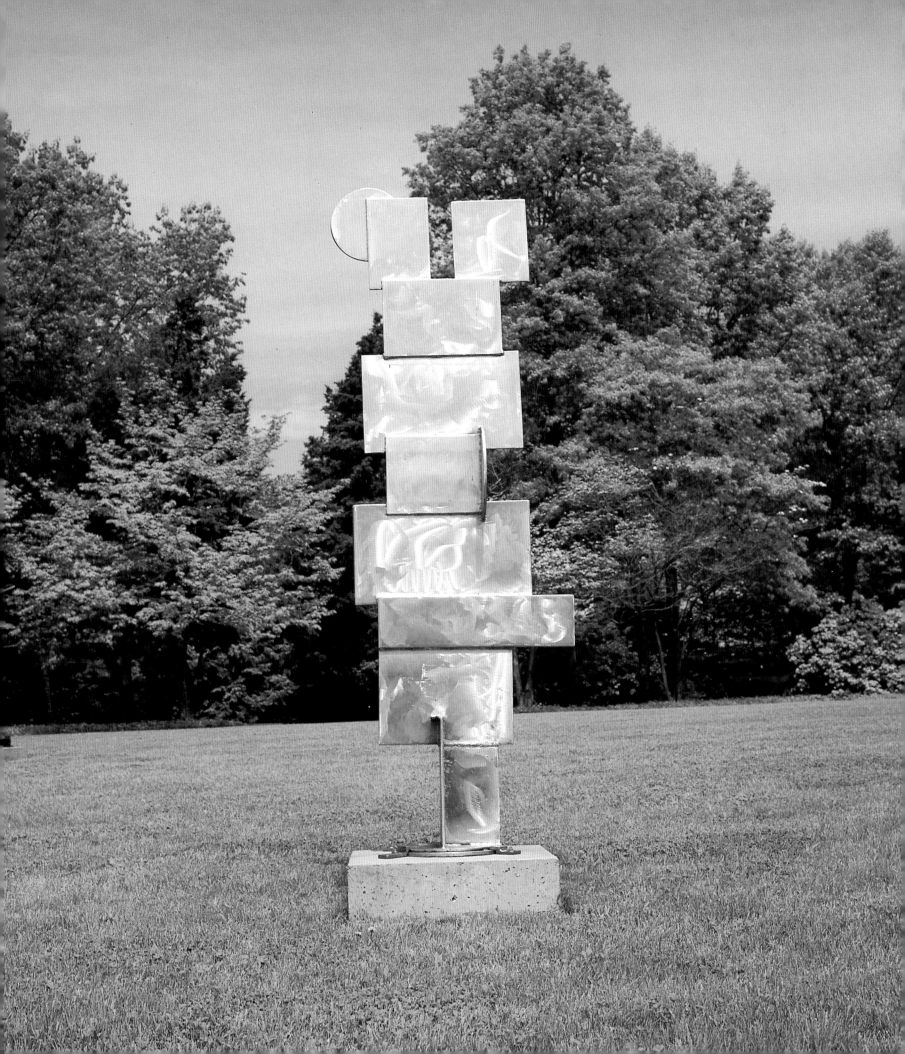

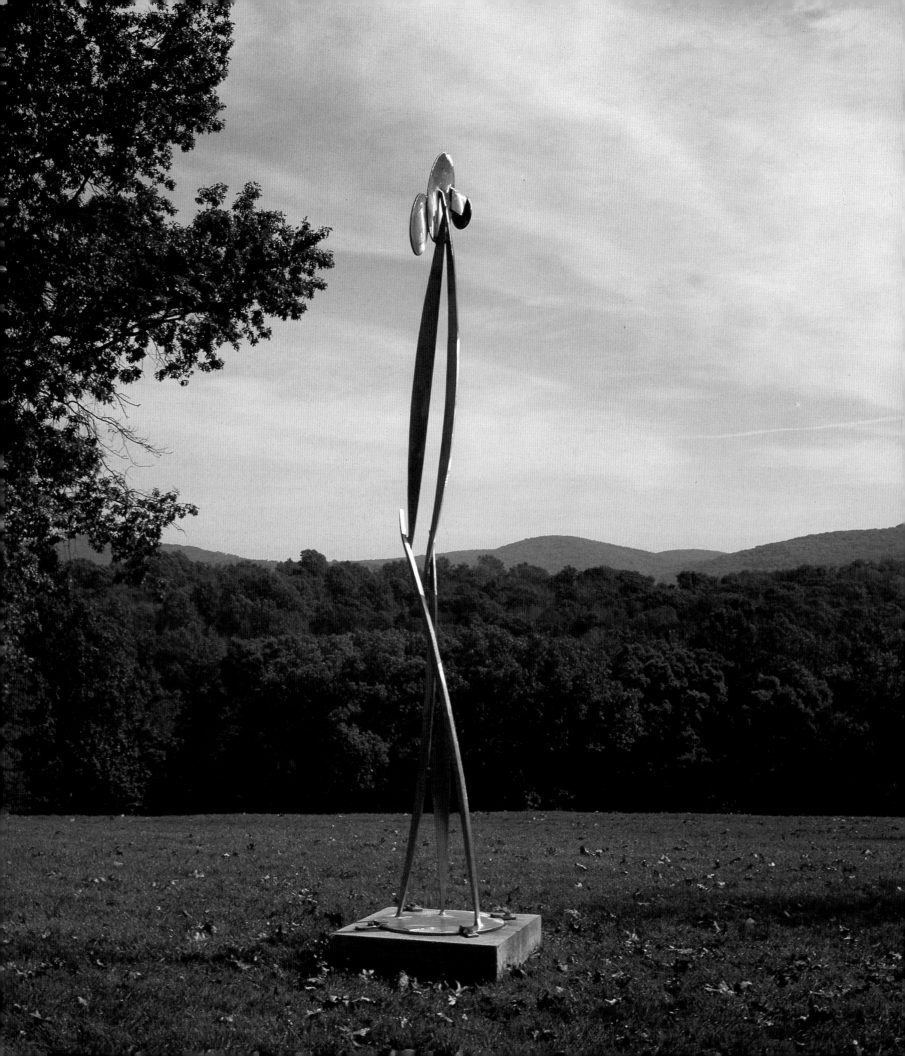

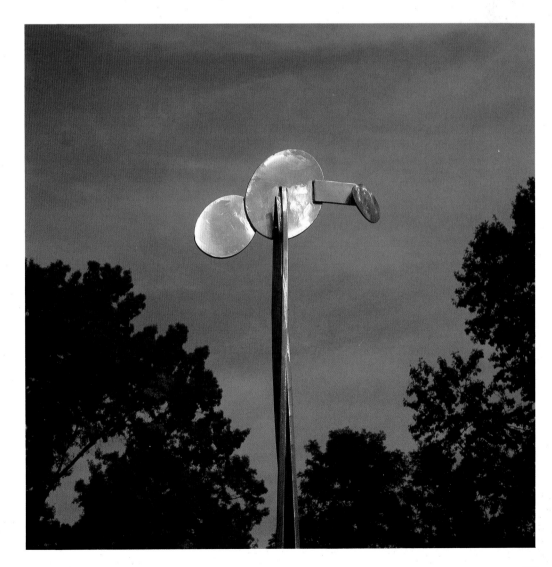

David Smith
Three Ovals Soar, 1960, and detail
Stainless steel, 11'3½″ × 33″ × 23″

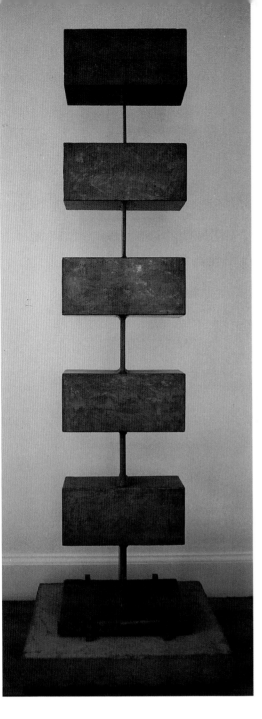

The still life also appeared in one of the last series of sculptures Smith made before his death. In 1962 he was invited to Italy to participate in the Spoleto Festival and was given studio space by the Italian national steel company, Italsider, in their abandoned factories at Voltri. In the space of a month he made twenty-seven sculptures from the discarded elements he found in the factory, including tools and the irregular ends of steel sheets. When he returned from Italy, he brought a lot of this material with him to Bolton Landing and continued the series of Voltri sculptures under various titles: Volton, Voltri-Bolton, V. B. Storm King's sculpture, *Volton XX* (1963), is a workbench still life from the group executed at Bolton Landing, incorporating both tools—wedges and tongs, for example—and abstract elements.

Other of Smith's sculptures verged on total abstraction. One of the earliest of these in the Storm King collection is *Five Units Equal* (1956), a curious work in the context of the rest of Smith's production. It is made of steel painted chartreuse, and while it bears some relation to the totems, it is a singularly restrained work, composed only of five rectangular elements stacked one on the other. Though it anticipates Smith's late series of stainless steel Cubis—assemblages of stacked rectangular units—the latter are generally much more irregular and exuberant in their composition. The true descendants of a sculpture like *Five Units Equal* may be the Minimalist works of various other artists made during the mid-1960s.

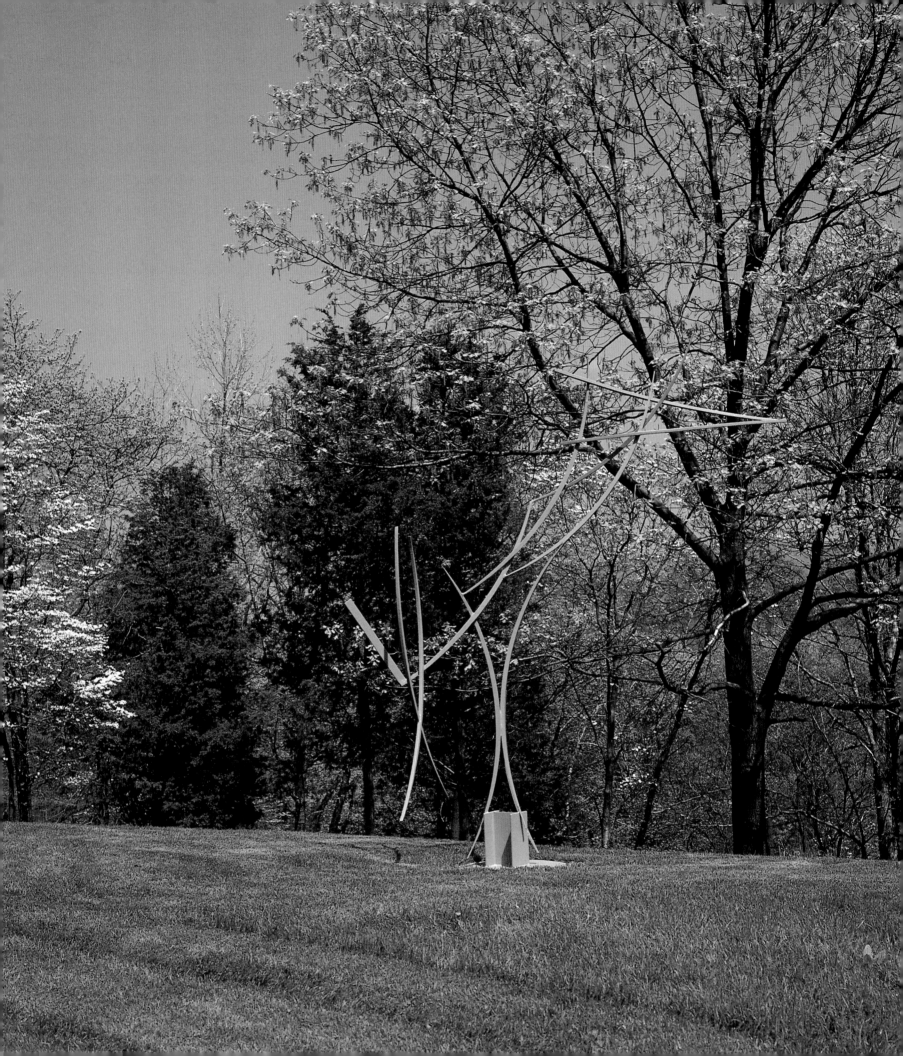

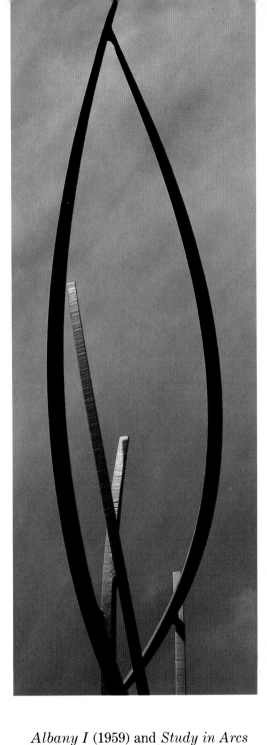

David Smith
Study in Arcs, 1959, and detail
Steel (painted pink), 132″ × 115½″ × 41½″

Albany I (1959) and *Study in Arcs* (1959) likewise appear thoroughly abstract. The compositional focus of the latter is well explained by its name, though the words hardly do justice to its delicacy and grace. *Albany I* is the first of a series of fourteen works, all but the last two of which were painted black. The title here refers to the place where Smith purchased the material for the sculptures. "The only tangible was the place where I bought the steel," Smith explained. "They are otherwise abstract."[15]

The two remaining works in the Storm King collection, *Raven V* (1959) and *Becca* (1964), however, reveal that some of Smith's apparently abstract works can carry a subtle narrative or representational content. *Raven V* develops a theme in Smith's earlier work, that of the animal form cantilevered from a single support. Here, tank tops are used to suggest the head and body of the creature, with a winglike form above. But the many chopped elements of this sculpture give it a fragmented look, suggesting more interest in the physics of flight than in the surface characteristics of the bird.

The same can be said of *Becca*, which is one of a number of sculptures titled with the nickname of one of Smith's two daughters. The first was inspired by a photograph of the girl running; this *Becca*, one of Smith's last sculptures, embodies all the energy and animation of the child.

This acquisition of thirteen sculptures by David Smith forever altered the character of the Storm King Art Center, for Smith's legacy suffuses the collection. His technique of welding metal components directly into sculpture was taken up by a subsequent generation of American sculptors, many of whom are represented at Storm King.

David Smith
Raven V, 1959
Steel and stainless steel, 58″ × 55″ × 9½″

OPPOSITE:
Becca, 1964, and detail
Steel, 78″ × 47½″ × 23½″

More importantly, the monumentality and heroism implicit in his work were seized upon and made more explicit by others in the years after his death: this too is evident at Storm King. Further, the acquisition set an important precedent for the Art Center, inspiring a policy of collecting work by those judged to be major figures in modern sculpture. It would be several years before this policy was firmly settled: in the early 1970s a series of exhibitions called *Sculpture in the Fields* introduced an eclectic array of large three-

dimensional works to Storm King, many of them on loan. But by the middle of the decade the Art Center had resolved its "major mission" and embarked on a considered course of acquisitions and exhibitions (the latter including David Smith in 1976, Alexander Liberman in 1977, Isamu Noguchi and Alexander Calder in 1979, Charles Ginnever, Douglas Abdell, and Mia Westerlund Roosen in 1980, Anthony Caro in 1981, Barbara Hepworth in 1982, Henry Moore in 1983) that would establish Storm King as one of the few places to see a significant representation of high-quality, large-scale sculpture of the postwar years.

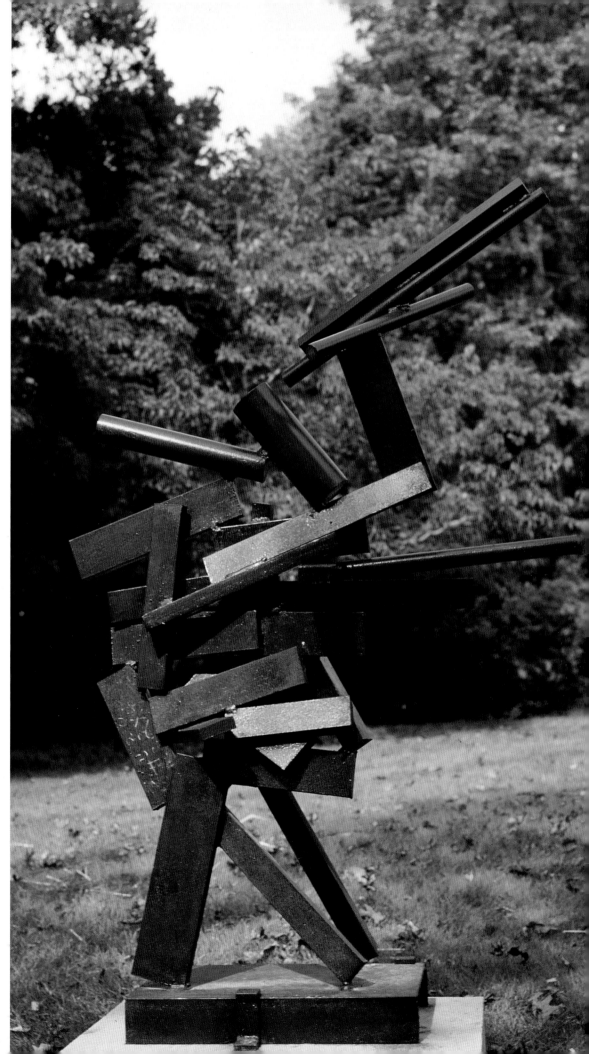

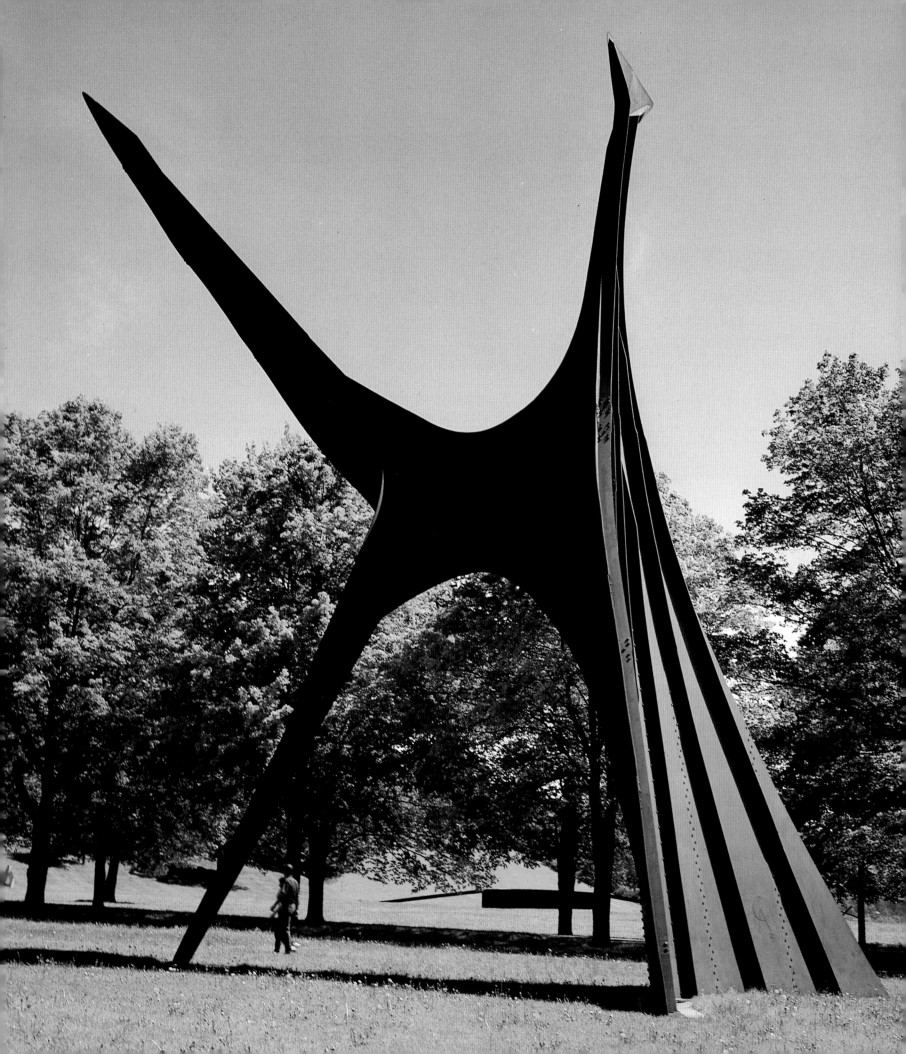

In the collection today, it is the monumental abstract works in steel that predominate. A visitor is literally greeted by Alexander Calder's *The Arch* (1975), which soars to a height of fifty-six feet and stands alone in a field by the entrance to Storm King. Calder, the son and grandson of sculptors, was another pioneer in the development of an American sculpture of heroic dimensions. His early works were smaller and more whimsical, however. In Paris during the late 1920s Calder first caught the attention of the art world with his *Circus*, a collection of toylike human and animal figures made from wire that he would manipulate to delight visitors to his room in Montparnasse. A group of kinetic sculptures followed, some motor- or crank-driven and some that hung in a delicate balance and circled gently in the breeze. These last were christened "mobiles" by Marcel Duchamp; when Jean Arp heard the name he responded, with reference to Calder's motionless works, "What were those things you did last year—stabiles?"[16] These two groups of sculptures—mobiles and stabiles—thereafter became Calder's trademarks. Both grew to enormous proportions, while never entirely forsaking the sense of playfulness that was an important element of his early work. Calder learned from many stylistic sources: the capricious lines and visceral shapes of Joan Miró, with whom he became friends in 1928; the simple geometry and primary colors of Piet Mondrian, whose studio he visited in 1930; and the formal logic and planar surfaces of Constructivism. Yet these elements were absorbed into an idiom that was entirely his own.

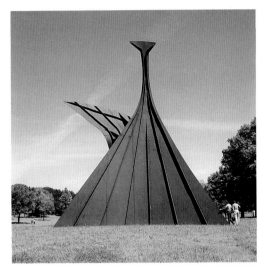

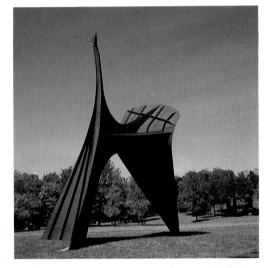

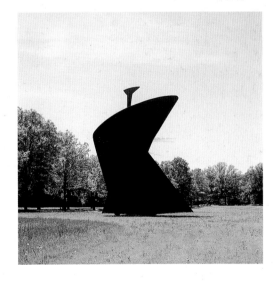

Alexander Calder
The Arch, 1975, multiple views
Steel (painted black), 56′ × 44′ × 36′

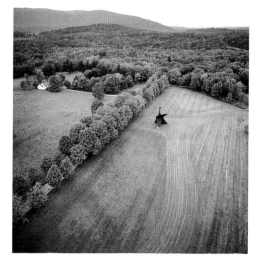

While some of Calder's sculptures
reached slightly larger than human
dimensions in the 1930s and 1940s, it
was in the 1950s that he began to ex-
plore the possibilities of truly monu-
mental work. A giant mobile was
commissioned for Kennedy Airport in
New York in 1957, while a combined
mobile and stabile—a freestanding
mobile—was executed for the Unesco
Building in Paris in 1958. Calder's
late years belong to the massive sta-
biles, a number of which were com-
missioned for public spaces around
the world: Spoleto in 1962; Lincoln
Center, New York, in 1965; Expo 67,
Montreal, in 1967; and subsequently
Grand Rapids, Chicago, and many
others. The list is impressive. Storm
King's stabile is the last the artist
completed before his death in 1976.
Acquired from his estate, it was as-
sembled at the Art Center, where it
received its final coat of black paint.
It has all the gravity and grace of
Calder's monumental works, yet
it also has humor. The uppermost
elements—an elongated neck and
wedge-shaped head, perhaps—recall
Smith's *Personage of May*, revealing
Calder's similar debt to Surrealism
and his embrace of organically sug-
gestive abstraction.

Alexander Calder
The Arch, two views

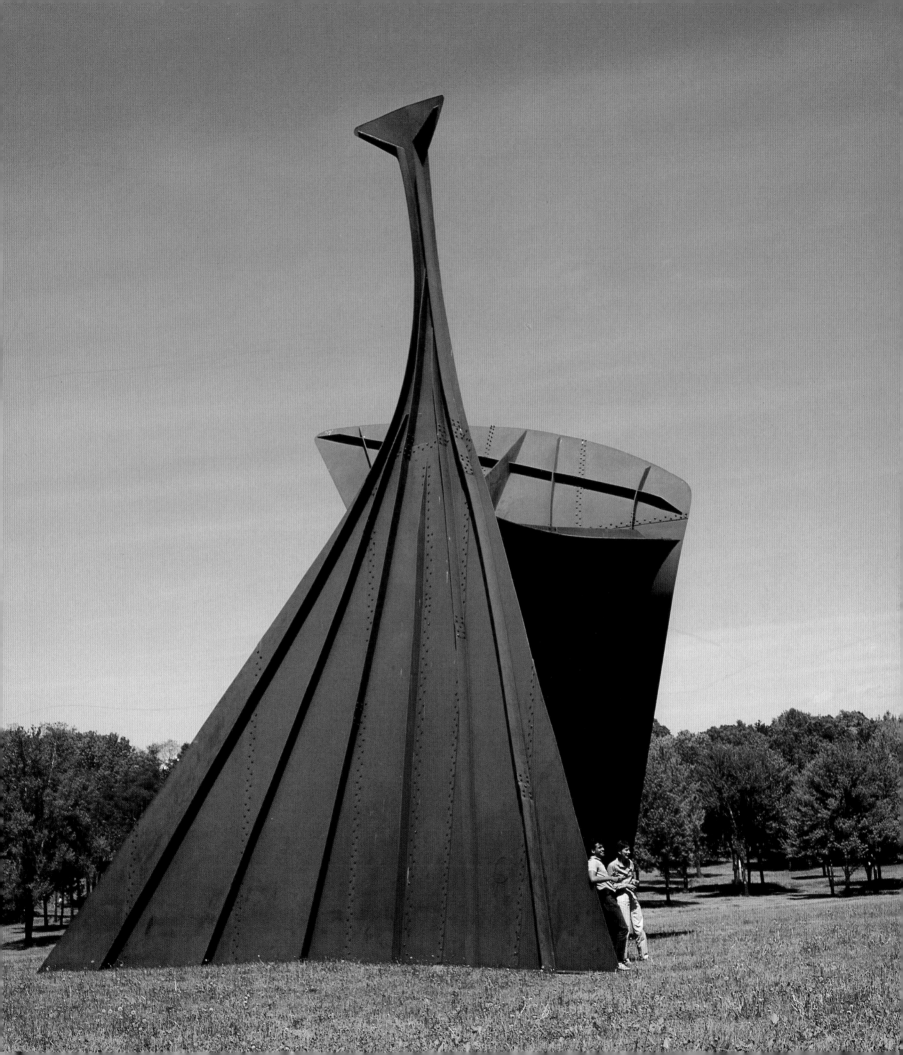

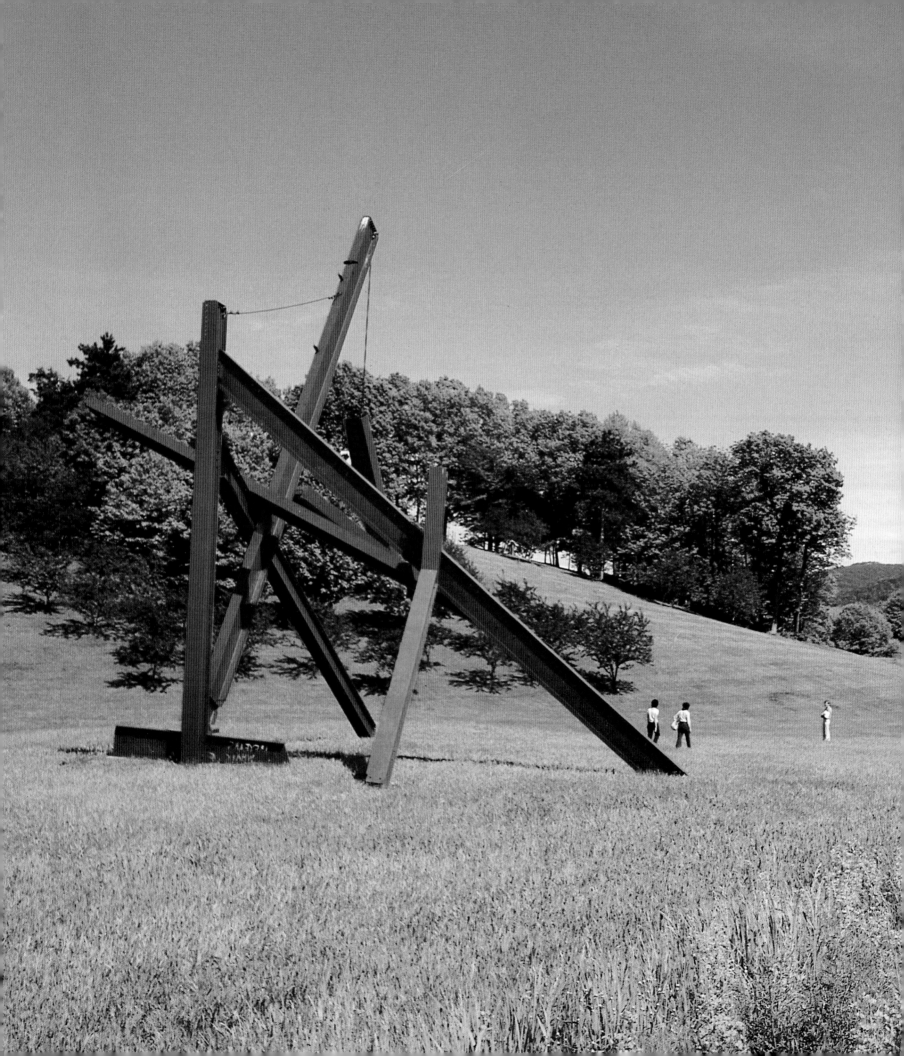

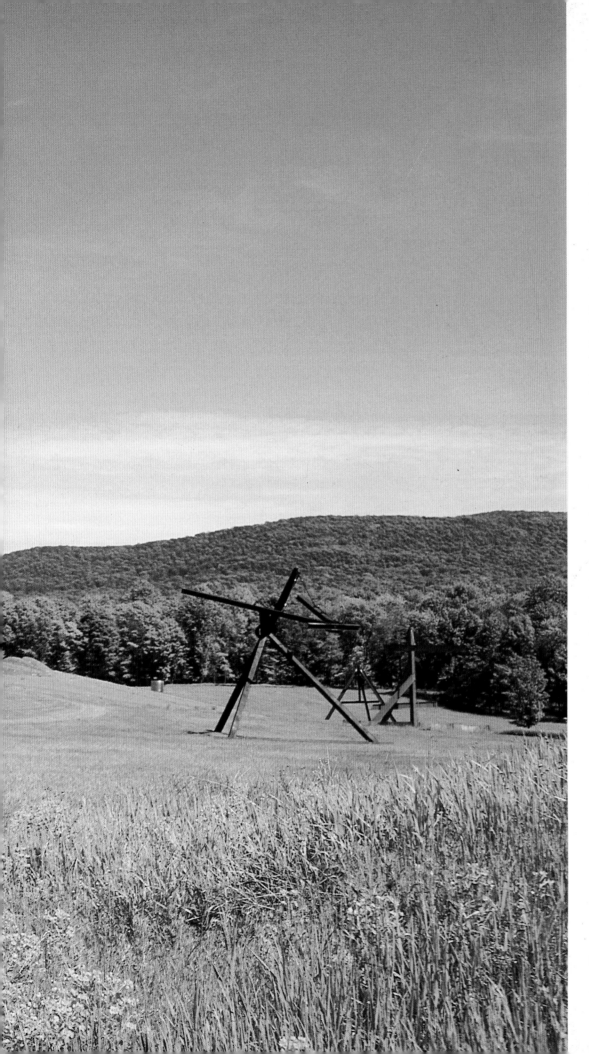

Many of the attributes of Calder's late sculptures—their imposing dimensions, their industrial materials, their playful combinations of static and kinetic elements—appear in the work of Mark di Suvero, an artist of a younger generation who began creating monumental sculpture in the mid-1960s. But unlike Calder, whose large works were industrially fabricated from small maquettes, di Suvero works directly with his materials at actual scale. Using enormous winches and cranes, he positions massive steel I-beams, then cuts, welds, and rivets them himself. Many of di Suvero's early works were incongruous combinations of found objects: weathered timbers, rusted metal, rubber tires. They often had moving parts, hanging from cables or swiveling on ball bearings, that invited pushing and climbing; some were even swings that could be ridden. The works in the Storm King collection—*Mother Peace* (1970) and *Mon Père, Mon Père* (1973–75)—as well as the two on long-term loan—*Are Years What? (For Marianne Moore)* (1967) and *One Oklock* (1968–69)—all include kinetic elements, weighty beams suspended on cables thirty-five or forty feet above the ground. Di Suvero describes these swinging components as "the real dimension," an effort to "make [the sculpture] living—interacting."

Sculptures by Mark di Suvero

Not surprisingly, given their size, the basic vocabulary for these colossal structures is architectural. It is a vocabulary of weight and balance and support, of portals and arches, of interior and exterior space. Yet the architectural vocabulary belies the essential emotionality of the pieces. To begin with, the suspended elements seem vaguely menacing from beneath. But more importantly, the sculptures carry references to the artist's own emotional concerns. *Mother Peace*, made at the height of the Vietnam War, expresses in its solid verticality as much as in its incised peace symbol the force of di Suvero's opposition to American involvement in that conflict. Soon after this piece was completed he left for Europe, where he remained until the end of the war, working, among other places, in the steelyards of Chalon-sur-Saône, France. *Mon Père, Mon Père* was executed there. It is a requiem for his father, who died while di Suvero was in exile. While the symbolic masculinity of this piece is apparent, di Suvero also speaks of it in terms of conjoining vectors, of "forces through the hole in the center," and of "the emptiness that makes things useful." There are two such crossings, two emptinesses in this work, one in motion, the other at rest.

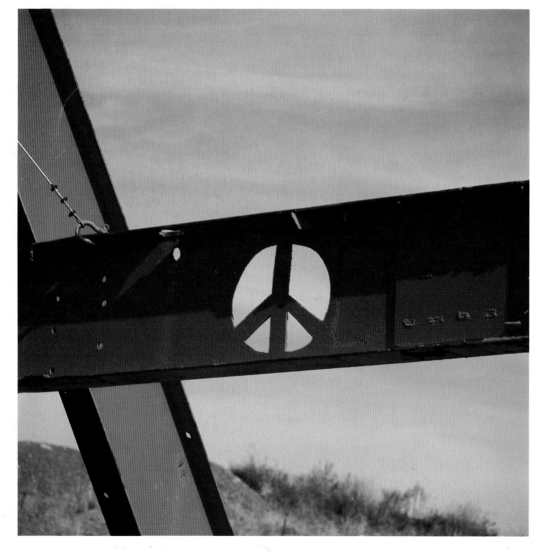

Mark di Suvero
Mother Peace, 1970, and detail
Steel (painted orange), 39′6″ × 38′5″ × 32′8½″

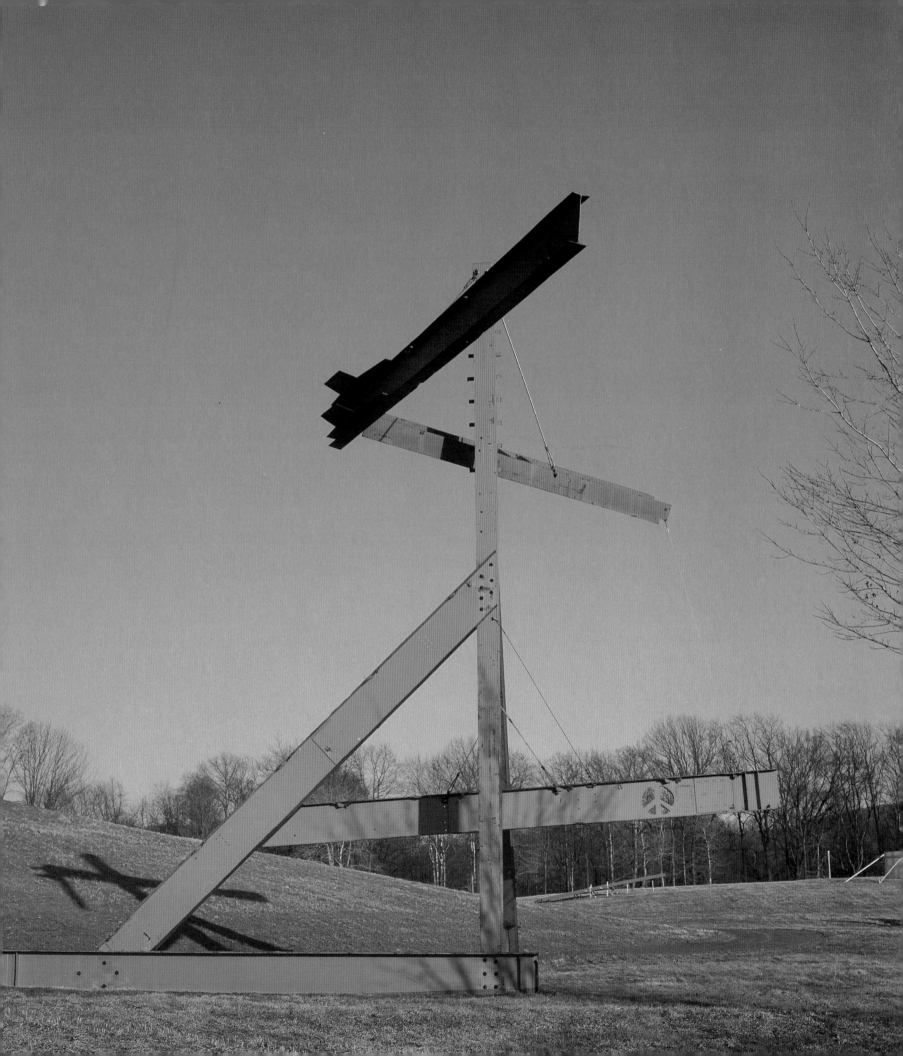

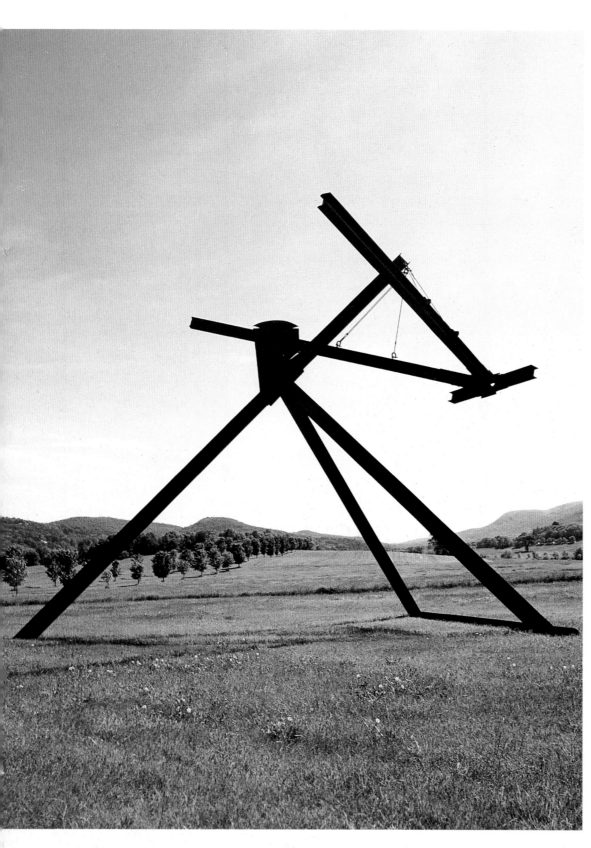

In 1975, at the end of his stay in France, di Suvero became the first living sculptor to have his work exhibited in the Tuileries garden in Paris. That autumn he was given a retrospective at the Whitney Museum of American Art in New York. Concurrent with this exhibition, a dozen of his large-scale works were installed at outdoor locations throughout New York City, including Flushing Meadow, Astoria Park, the Conservatory Gardens in Central Park, Battery Park, and Silver Lake Park. At the close of the exhibition di Suvero had no place to keep many of these works, as he had yet to reestablish a studio in the United States. At the suggestion of the Art Center, five of them were sent on long-term loan to Storm King, beginning in the spring of 1976. No doubt the experience of seeing so many of his sculptures installed in parks in Paris and New York convinced di Suvero and the Art Center of the wisdom of this arrangement. It continues to please everyone involved: two of the sculptures were acquired by the Center in 1981, while two of the others remain on loan to this day.

LEFT TO RIGHT:

Mark di Suvero
Mon Père, Mon Père, 1973–75
Steel, 35′ × 40′ × 40′4″

One Oklock, 1968–69
Steel, 28′ × 46′6″ × 39′

50

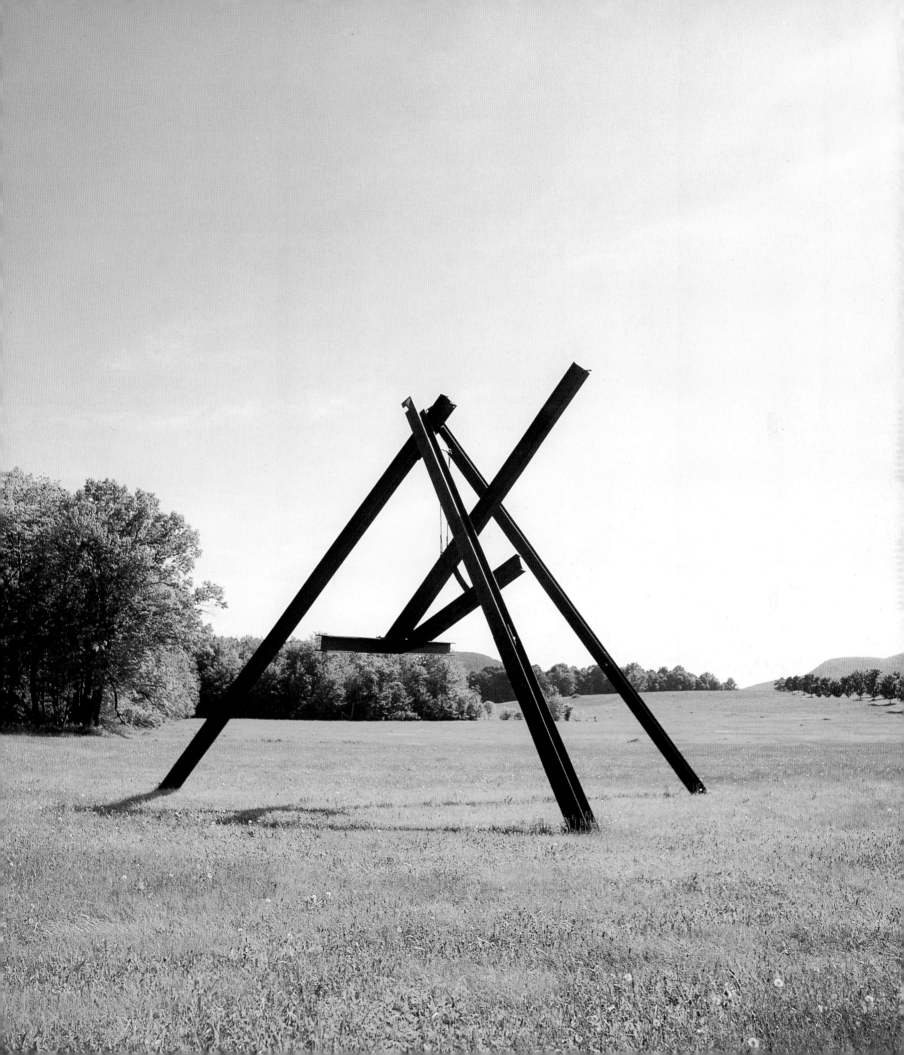

Alexander Liberman also works directly with his materials at their actual scale. His basic unit is the steel gas-storage tank, a cylindrical module variously six or twenty-four feet in length. Liberman collects these components at his outdoor studio in Connecticut, where they lie in rusty heaps until he is ready to use them. Seldom are they left in their original form. Some are sliced into ellipses, set on the diagonal, and cantilevered high in the air. Others are crumpled or set on pointed ends. A few retain their rusty finish, but most that are intended for public installation are painted a uniform white or orange.

Liberman, who was a guest at Bolton Landing the weekend before Smith died, has exploited more the heroic than the humorous aspects of monumentality. Even the names confirm this. One of the first of Liberman's monumental pieces was *Adam* (1970), another *Adonai* (1971), a Hebrew word for God. The latter was a particularly ambitious piece for Liberman. He explained: "I had gone to Chartres. I was trying to analyze why cathedrals started with the basic portal. So I started with the basic portal, the two vertical cylinders of *Adonai*. Then there's a nave. If you look at the long horizontal cylinder of *Adonai*, that's my imaginery nave. . . . You build your own imaginary cathedral."[17] The third Liberman in the Storm King collection, *Iliad* (1974–76), has a similarly august theme, this one the heroic struggle of Homer's epic.

Alexander Liberman
Adam, 1970
Steel (painted orange), 28'6" ×
29'6" × 24'

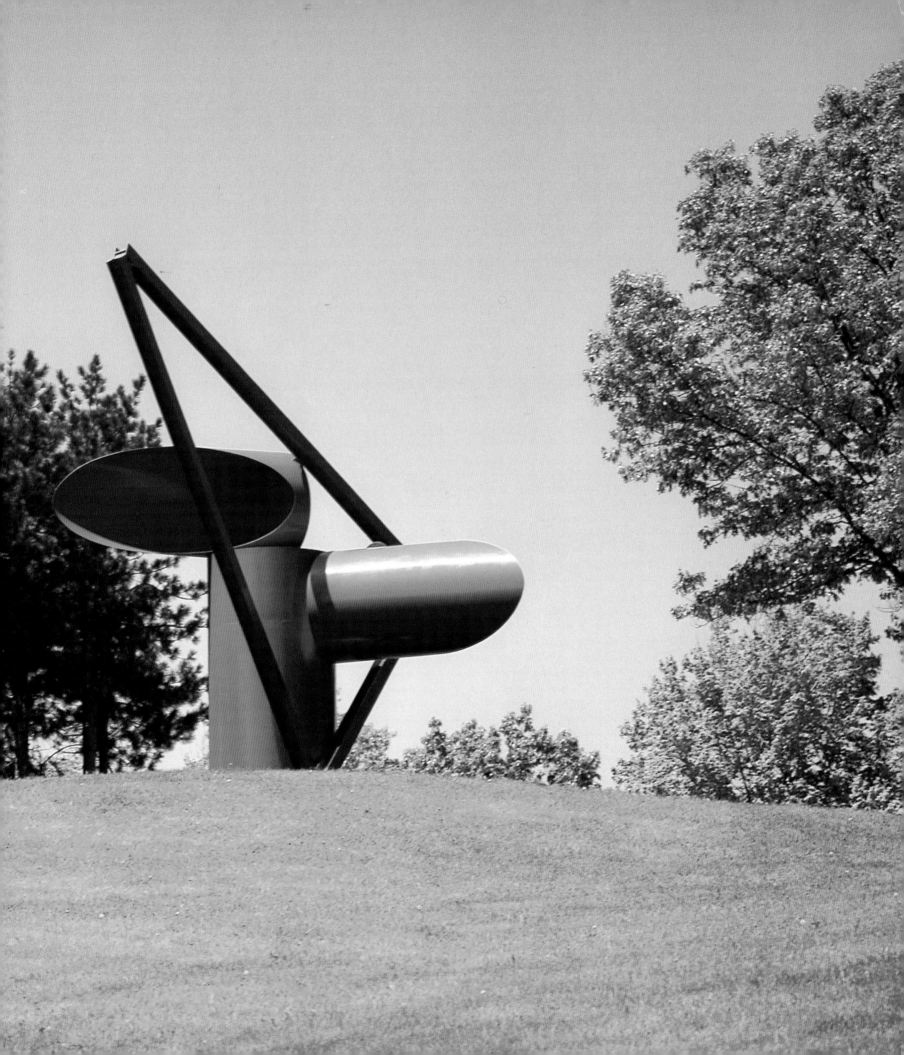

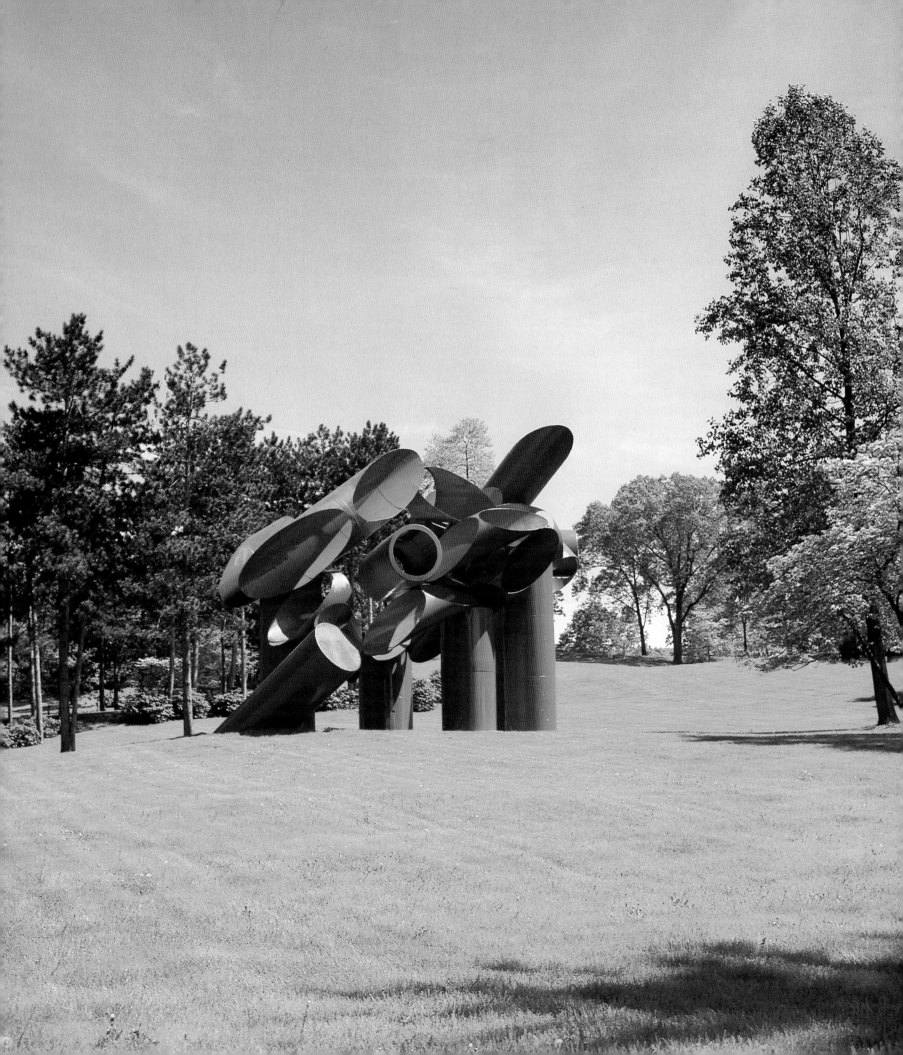

LEFT TO RIGHT:
Alexander Liberman
Iliad, 1974–76
Steel (painted orange), 36′ ×
54′7″ × 19′7″

Adonai, 1971
Steel, 35′ × 50′ × 75′
Photograph by Leonid D. Lubianitsky

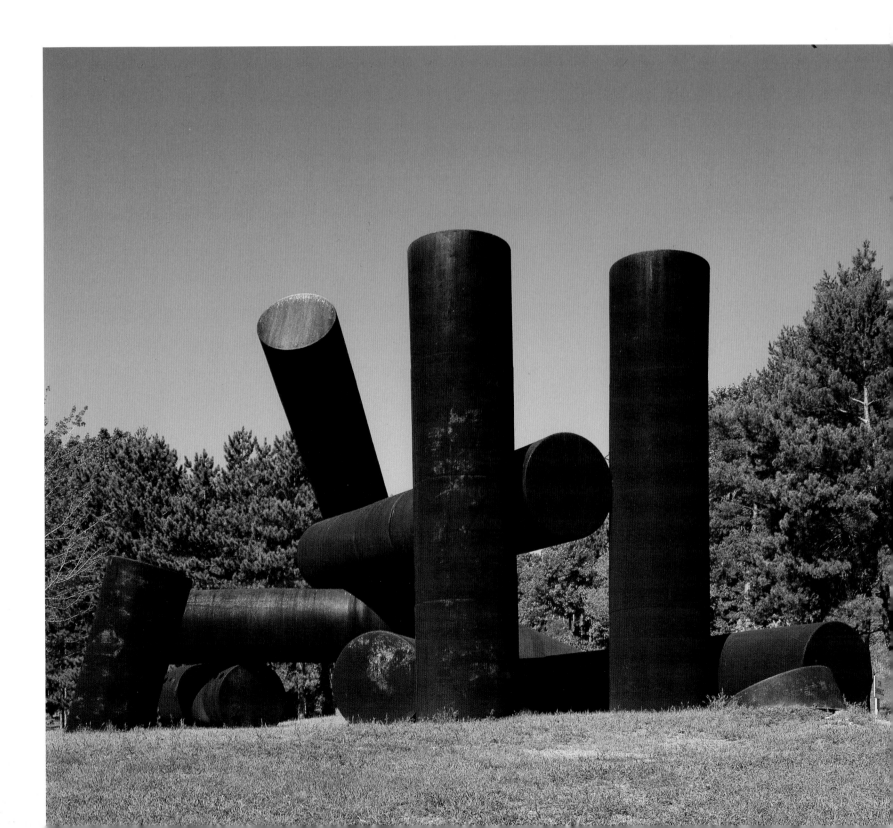

Numerous other direct metal sculptures are included in the Storm King collection. Yet a similarity in technique disguises a remarkable range in artistic purpose. Several of these sculptures are composed of welded steel in the Abstract Expressionist tradition, including *Konkapot II* (1972) by Herbert Ferber, an artist of David Smith's generation, and *Australia No. 9* (1969), an assemblage by Richard Stankiewicz. Others are more restrained, in the tradition of the lucid formal organization of the Constructivists: *Six Cylinders* (1968) by William Tucker, for example. Still others owe a direct debt to David Smith. Two are by Anthony Caro, an English sculptor whose work shifted dramatically from figurative bronzes to metal assemblages after a visit with Smith in 1959. Almost from the outset, however, Caro's work was notably less monolithic or totemic than Smith's, with its elements strung out along the ground in a rather disembodied way. Isaac Witkin is another artist in this tradition; he was a student of Caro's at the St. Martin's School of Art in London in the late 1950s and subsequently took over from Caro on the faculty at Bennington College in Vermont. He is represented in the Storm King collection by five sculptures.

CLOCKWISE FROM RIGHT:
Richard Stankiewicz
Australia No. 9, 1969
Steel, 89″ × 36″ × 48″

William Tucker
Six Cylinders, 1968
Steel (painted dark brown), 55″ × 94″ × 58½″

Herbert Ferber
Konkapot II, 1972
Cor-ten steel, 5′9″ × 4′ × 9′10″

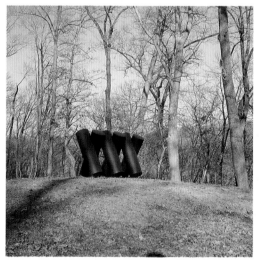

CLOCKWISE FROM RIGHT:

Isaac Witkin
Kumo, 1971
Cor-ten steel, 16′3″ × 13′4″ × 12′2″

Anthony Caro
Seachange, 1970
Steel (painted gray), 35″ × 111″ × 60″

Anthony Caro
Reel, 1964
Steel (painted red), 34¼″ × 107″ × 37¾″

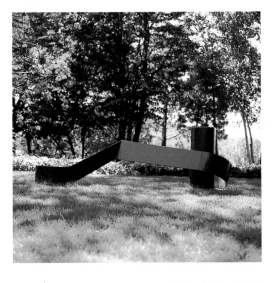

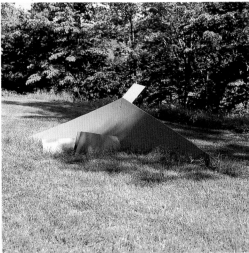

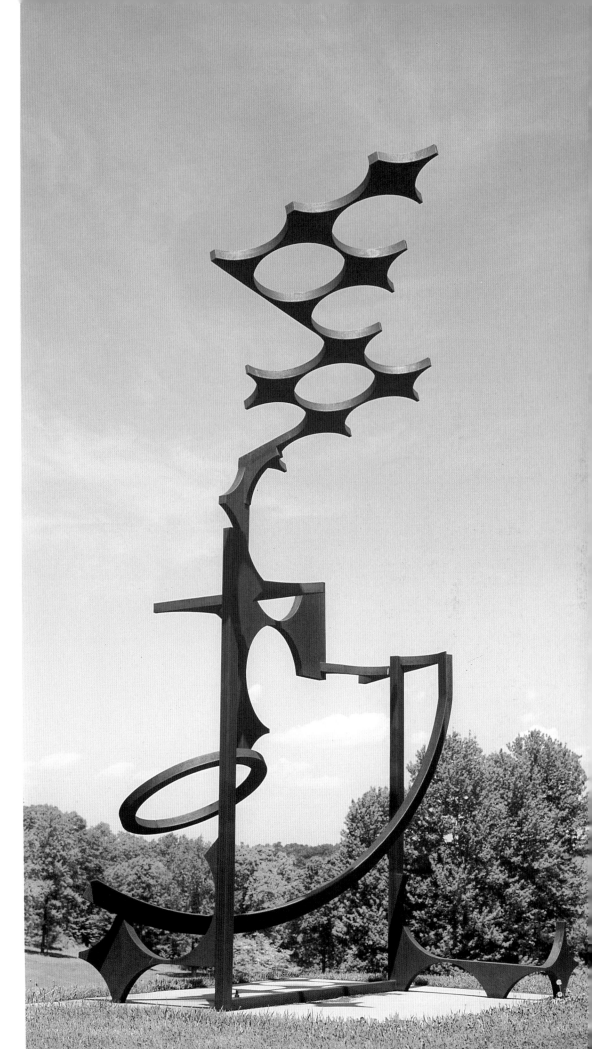

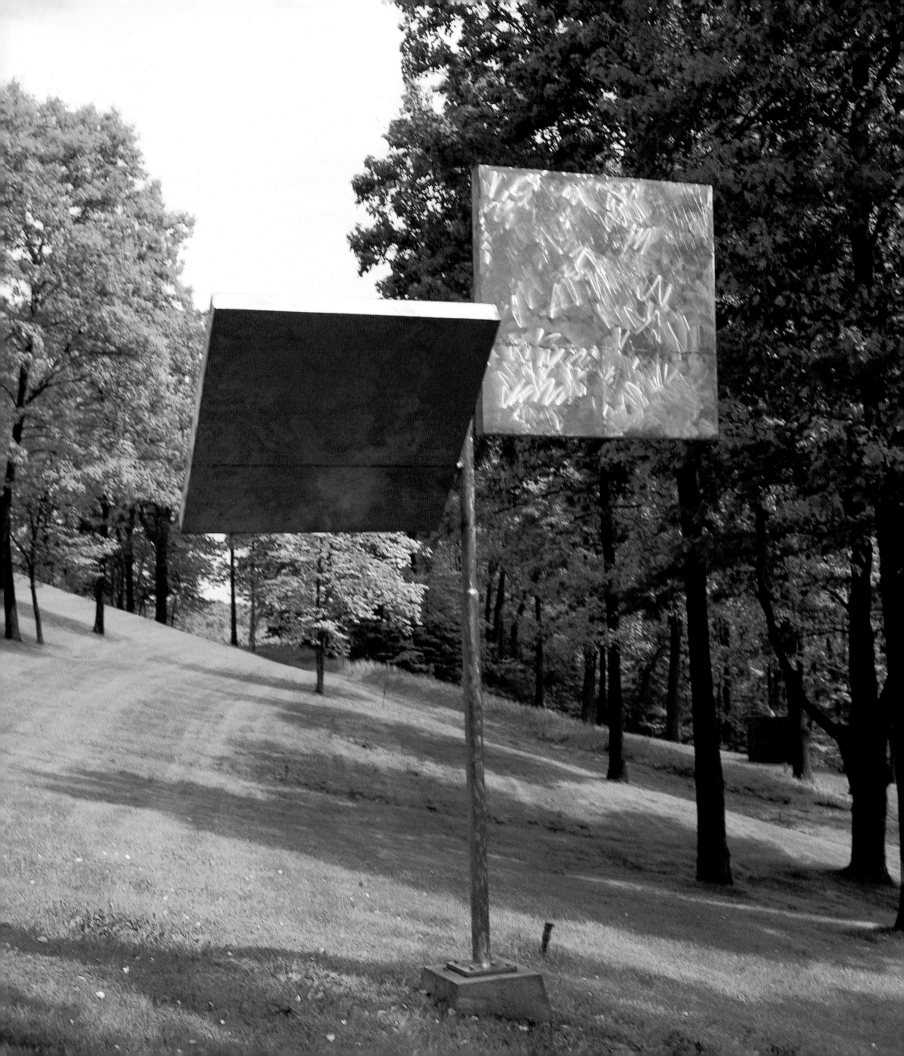

George Rickey developed welded-metal sculpture of an entirely different sort, exploring the possibilities of motion as Calder had with his mobiles. *Two Planes Vertical-Horizontal II* (1970) is a kinetic work: two large rectangles that pivot gently in the breeze. It also exploits the light-reflecting, form-dissolving burnished stainless steel surfaces of Smith's Cubis. David von Schlegell took the dissolution of form yet another step with his *Untitled* (1972), known informally as the "three open cubes." This is a sculpture concerned as much with the subtle demarcation of space as it is with the positive expression of form. Charles Ginnever created another perceptual puzzle with his *Fayette: For Charles and Medgar Evers* (1971), a work that looks volumetric but in fact is nearly flat. Though abstract, this work serves a commemorative purpose, recalling the slain civil rights leaders.

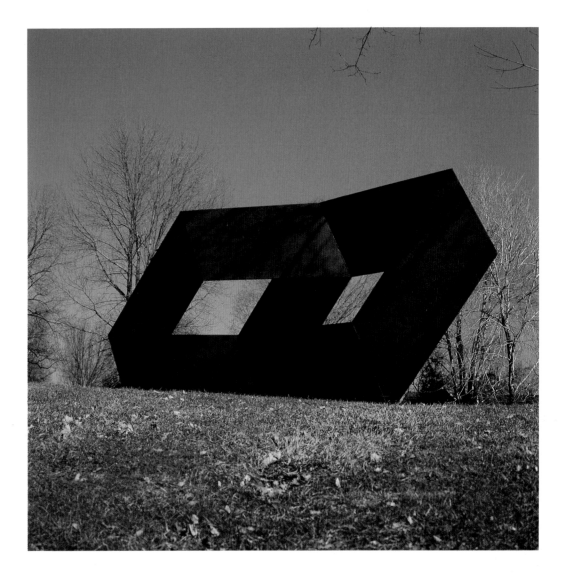

LEFT TO RIGHT:
George Rickey
Two Planes Vertical-Horizontal II, 1970
Stainless steel, 14′7⅝″ × 10′5″ × 6′3″

Charles Ginnever
Fayette: For Charles and Medgar Evers, 1971
Cor-ten steel, 8′4″ × 16′8″ × 18″

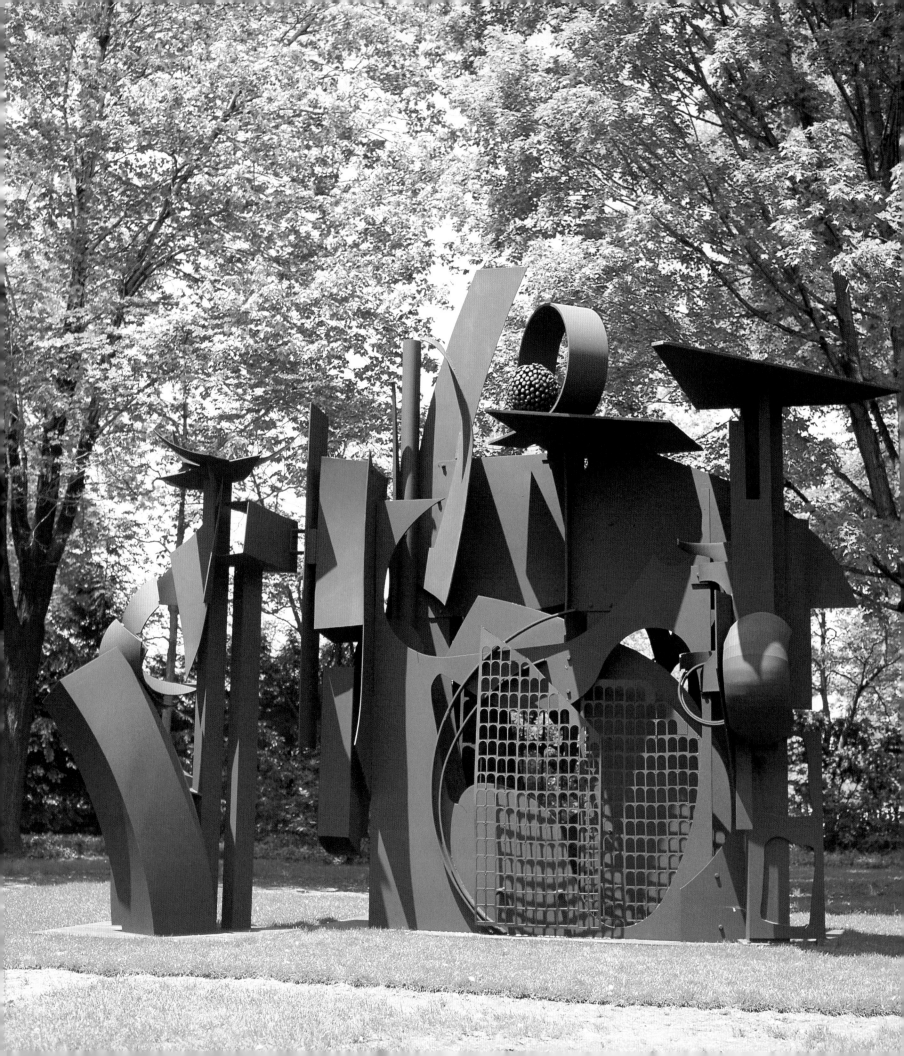

That the tradition of abstract direct metal sculpture remains important to the Art Center is demonstrated by its most recent major acquisition, *City on the High Mountain* (1983) by Louise Nevelson. The artist became known several decades ago for her assemblages of found objects, notably fragments of furniture or decorative woodwork from old houses. Originally small, these grew to room-size proportions by the early 1960s. Sometimes freestanding totems and sometimes clusters of individual boxes, these were always painted a uniform color; black, white, or gold. Too fragile for the elements, wood gave way to steel when Nevelson was called upon to create for the outdoors. Her steel sculptures are fabricated at a factory in Connecticut, but she maintains control of the work through constant supervision. Some parts are even welded directly by her, as was the spiked ball at the top of *City on the High Mountain*. Like her wood sculptures, this work has the character of a free-spirited and imaginative assemblage of found objects.

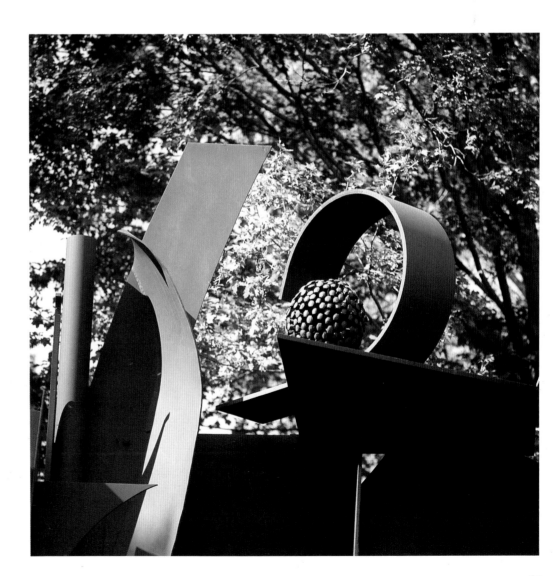

Louise Nelson
City on the High Mountain, 1983, and detail
Cor-ten steel (painted black), 20′6″ × 23′ × 13′6″

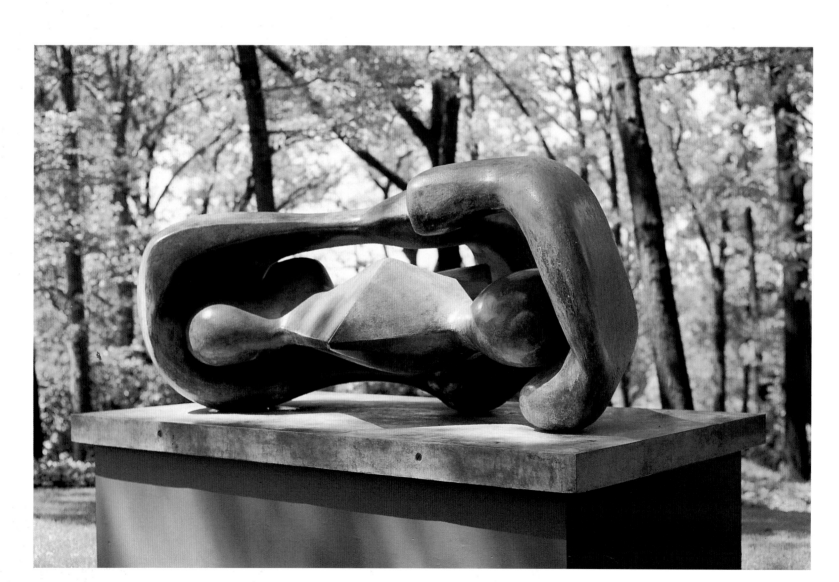

The wealth of direct metal sculpture at Storm King should not obscure the collection's considerable diversity. In particular, there are numerous works by those who have continued to work in carved stone or cast bronze. One of these is Henry Moore, the preeminent British sculptor. Moore's roots are equally in Surrealism and the massive stone carvings of ancient central America; he has always maintained a strong predilection for the figure. In the post–World War II years, these figurative sculptures have become more abstracted. His *Reclining Connected Forms* (1969) suggests only a distant relationship with the human body, though it is clearly derived from the reclining figure. It is subtly biomorphic, suggesting organic forms with its lithe curves and bone sockets with its interlocking parts.

Moore's compatriot Barbara Hepworth is represented in the Storm King collection by two works. She too worked extensively in bronze and in the tradition of biomorphic abstraction. The stately curves of *Pavan* (1956) suggest the motions of a courtly dance, while *Square Forms with Circles* (1963), for all its abstraction, maintains a spectral, totemic presence.

LEFT TO RIGHT:

Henry Moore
Reclining Connected Forms, 1969
Bronze (green patina), 38″ × 87¾″ × 52″

Barbara Hepworth
Square Forms with Circles, 1963
Bronze (green patina), 102¼″ × 60½″ × 9⅝″

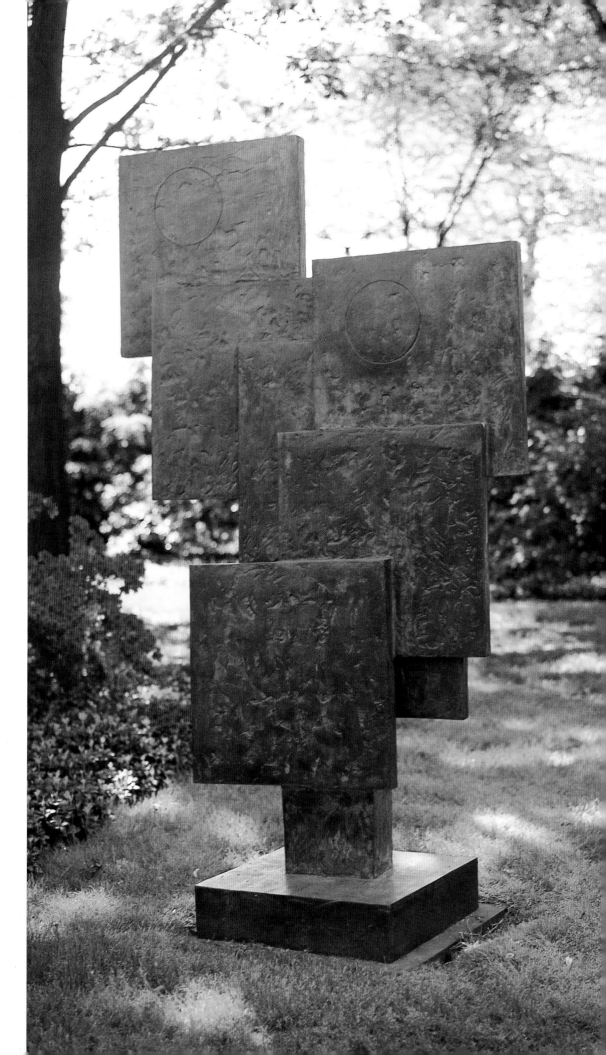

The collection also includes a coolly elegant work by Sol LeWitt, one of the principal exponents of a movement that has become known as Minimalism. Prevalent in the latter half of the 1960s, it was a reaction against the emotional expressionism that dominated both painting and sculpture in the 1950s and that continued to be of importance to many artists in the 1960s, such as Mark di Suvero. As exemplified by LeWitt's *Five Modular Units* (1970), Minimalism utilized a vocabulary of simple geometric forms and repeated, identical elements to eliminate all trace of the artist's hand or personal history. Instead, Minimalist sculptors wanted to draw attention to the physical properties of objects themselves—their weight, mass, surface, and volume—and to the perceptual processes by which we come to know them. In this sense, Minimalism is a misleading term, for while these are visually reductive sculptures, they aspire to a complex purpose.

Sol LeWitt
Five Modular Units, 1970, two views
Steel (painted white), 5'3″ × 5'3½″ × 24'3½″
Purchase, 1971.20

There are works in the Storm King collection by artists who defy categorization, who are thoroughly independent in their subject matter and their formal vocabulary. Louise Bourgeois is such an artist. Although she came of age with the Surrealists in France and later in New York, where many of them lived during World War II, she has always been something of an outsider, pursuing her own objectives independent of the movement. As a consequence, her sculptures have no predictable look. They can be suggestively biomorphic or entirely abstract, rigidly totemic or sensuously languid, discrete or environmental, autobiographical or utterly indecipherable. *Number Seventy-two (The No March)* (1972) is a small army of Carrara marble cylinders of different widths and heights, each with one end cut on the diagonal. The title provides a clue to the interpretation of this work: it is an image of resistance. Bourgeois explains that it was made at the time of the peace movement during the Nixon years but that this is only part of its meaning. It is more generalized in intent, evoking "helpless people who gang together to say no to the present order of things." Yet, as Bourgeois points out, it is "tender in spirit" and affirmative in its pristine, reflective surfaces.

Louise Bourgeois
Number Seventy-two (The No March), 1972
Marble, 10″ × 17′ × 10′

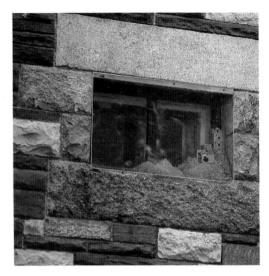

Charles Simonds
Dwellings, 1981
Clay (two parts), 9½″ × 13″ × 9″;
13″ × 22½″ × 9″

Charles Simonds is another such independent. His work over the last dozen years has chronicled the wanderings of an imaginary civilization he calls "the little people." Working with colored clay and tiny bricks, he creates landscapes and buildings that are the deserted dwelling places of people who have long since died or moved on. At Storm King their simple homes and ritual structures are found built into diminutive, hilly landscapes that are set upon two deep window ledges.

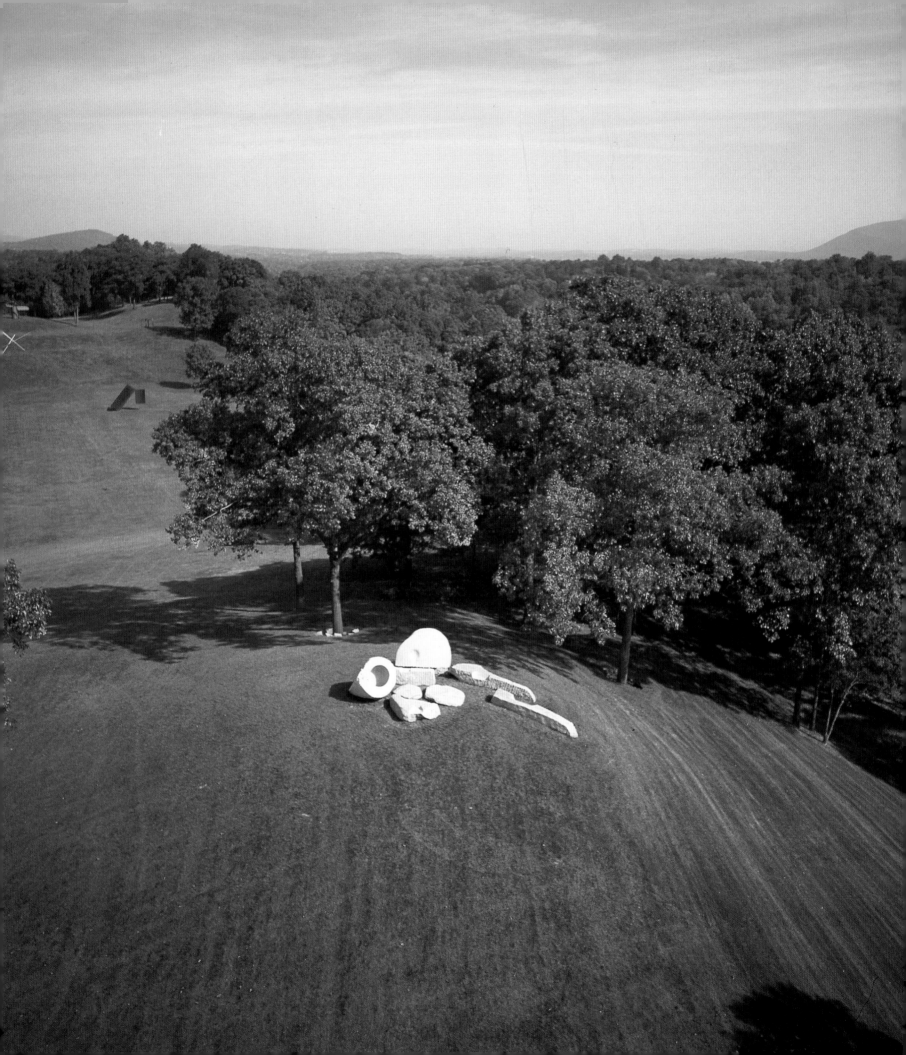

Finally, there is Isamu Noguchi. His sculptural yield rivals that of David Smith in its prodigiousness, and it is even more diverse, including stone and wood carvings, bronzes, theater sets, playgrounds, and public parks. Only one aspect of this variety is represented at Storm King, in the form of an ensemble of nine carved stones. Yet *Momo Taro* (1977), as it is called, is one of the artist's most ambitious and successful works. This monumental sculpture was created especially for the Storm King landscape. Noguchi visited the Art Center, was shown several sites, and was asked only to make a work in stone that would incorporate seating. He selected a site at the crown of a hill not far from the Art Center building, took photographs and measurements, and went off to contemplate the project. At his studio on the island of Shikoku, in Japan, where he spends part of every year, Noguchi assembled a quantity of huge granite boulders that would be the elements of his work. To Peter Stern, he wrote that he was "talking to the stones." One proved too large to work, so Noguchi split it in half. Necessity was indeed the mother of invention in this instance, for from that act was born the idea of *Momo Taro*: the sculpture is named for a Japanese folk hero who emerged from the split halves of a peach pit. Noguchi carved out the center of one of the standing stones, making a cavity into which one can comfortably climb and crouch in the fetal position. The organic metaphor is extended to the treatment of surfaces: the inside of this "fruit" is smooth, while the skin is rough. Others of the stones offer more conventional seats and sprawl along the ground like so many toppled giants.

Isamu Noguchi
Momo Taro, 1977, two views
Granite, 9' × 35'2" × 22'8"

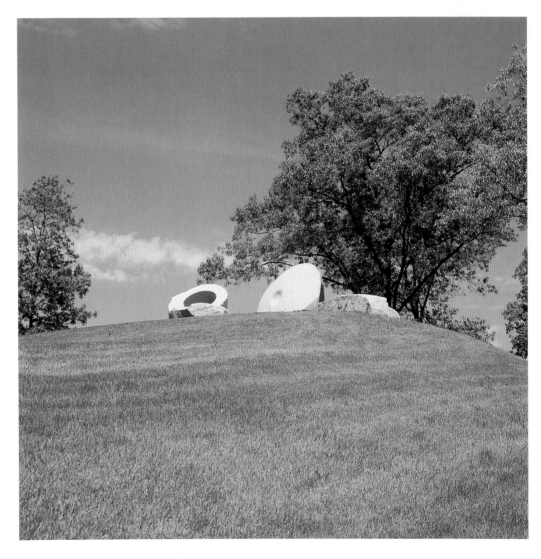

Isamu Noguchi
Momo Taro, details

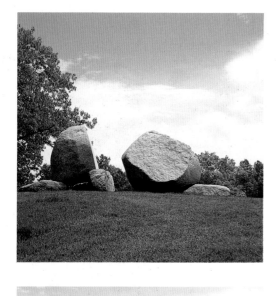

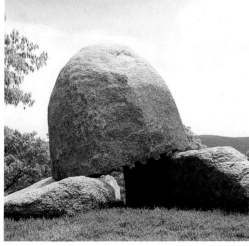

Many of Noguchi's early works displayed the unitary yet organically derived forms of the sculptor for whom he briefly worked as studio assistant in Paris in 1927: Constantin Brancusi. Yet Noguchi's art was soon to evolve its own aims. As he later explained, he sought "a larger, more fundamentally sculptural purpose for sculpture, a more direct expression of Man's relation to the earth and to his environment."[18] Noguchi found this larger purpose in a variety of environmental projects: gardens, parks, playgrounds, and public plazas. He first proposed works of this kind as early as 1933, but it was not until the mid-1950s that any were realized. There now are many: the Unesco Gardens in Paris, the Billy Rose Sculpture Garden in Jerusalem, the Chase Manhattan Bank Plaza Garden in New York, and the Philip A. Hart Plaza in Detroit, to name but a few. In some respects, *Momo Taro* represents a summation of Noguchi's landscape work. It retains all the formal characteristics of a sculpture, with its marvelously hand-carved monoliths disposed in an intriguing arrangement. At the same time, it invites participation—climbing and sitting. But it is not altogether clear where sculpture ends and landscape begins, for the work rests on the crown of a small hill created to Noguchi's specifications. *Momo Taro* is at once sculpture and environment, fulfilling both its artistic and its public purposes.

Three primary considerations figure into the choice of acquisitions for the Storm King Art Center: quality, durability, and appropriateness to the scale and drama of the landscape setting. As Peter Stern puts it: "We want major, large pieces that look good here. They have to hold their own against the landscape. The selection might seem arbitrary, but if you sit down and think about which artists really look right outdoors, only some come to mind." The Art Center's approach reflects a desire to collect works by acknowledged masters of modern sculpture. But it also turns on the matter of durability: works acquired for the collection must be of a material and quality of fabrication to withstand the extremes of temperature and precipitation characteristic of a northern climate. Storm King Director David Collens agrees: "Our concern is with the quality and maintenance of the works. We avoid the ephemeral. Will it last? Is it safe? We have to ask those questions."

Taking proper care of the sculptures that are acquired is a continuing challenge. Many of the works are either encased in plywood shelters or brought inside for the winter. Others are braced with cables for support against the heavy snows. Star Expansion Company of Mountainville has contributed expertise on the proper sorts of paints, bolts, and foundations for the sculptures. In addition to routine washing and waxing, some of the pieces require particular attention. Wire mesh was installed over the ends of the aluminum tubes that compose Kenneth Snelson's tensile structure, *Free Ride Home* (1974), to keep out flocks of nesting birds; holes had to be enlarged in the bottom of the tanks of one of the Liberman sculptures to facilitate water drainage. Five of David Smith's sculptures were moved indoors in the mid-1970s because they were discovered to be too delicate for the outdoors.

Considerations of durability and appropriateness might be expected to

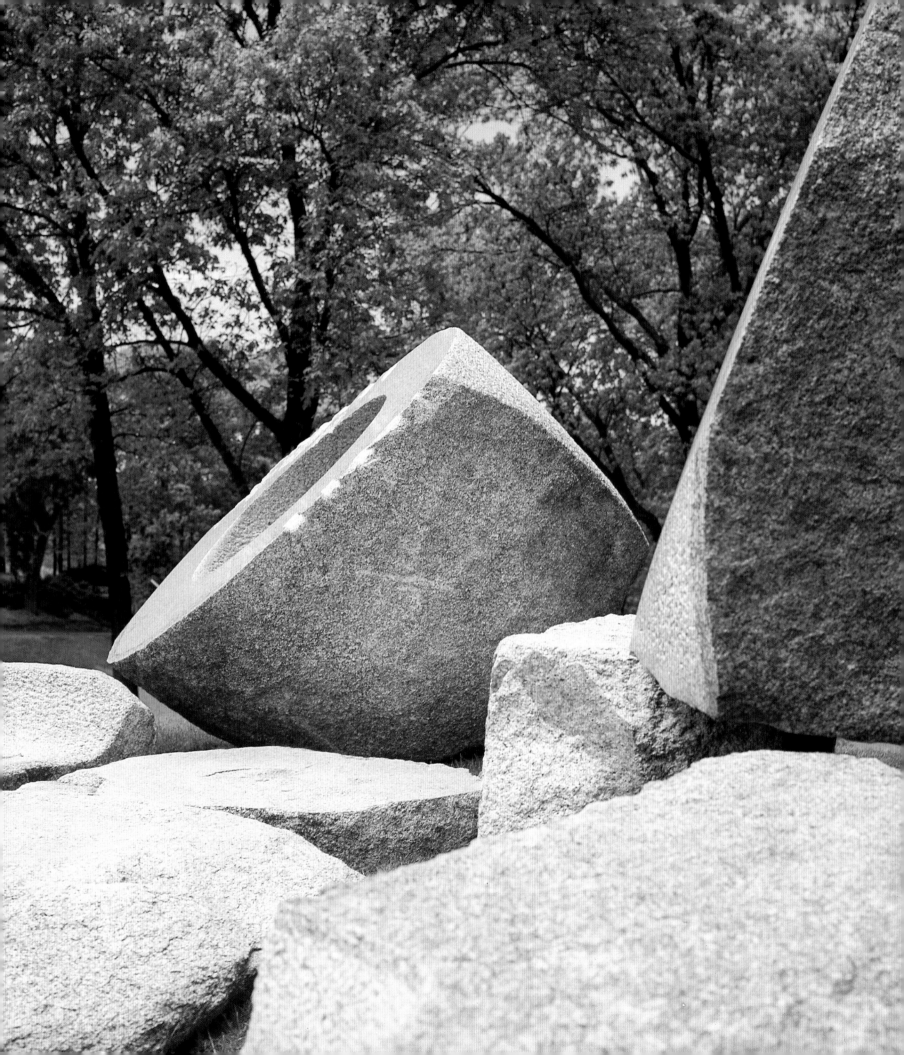

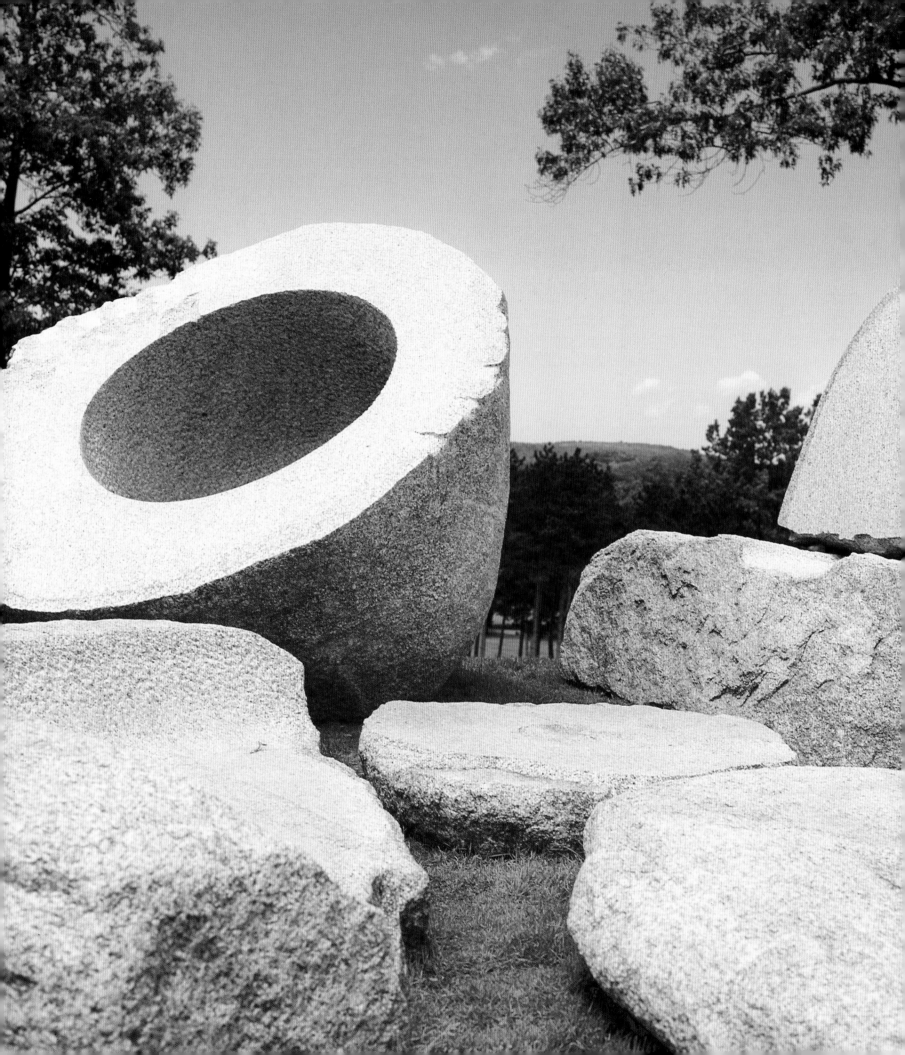

limit the extent to which the Storm King collection can fully reflect the practice and accomplishments of post–World War II sculpture. While no collection is ever without gaps, and while outdoor exhibition does preclude the acquisition of pieces made of more delicate materials, the presence of important works by Smith, Calder, Moore, Noguchi, Nevelson, di Suvero, Bourgeois, and numerous others—European and American, older and younger—indicates that Storm King effectively tells the story of recent sculpture both from the standpoint of diversity and of quality. What limitations are imposed by the out-of-doors are addressed by the acquisition of smaller, frequently more fragile sculptures housed in the Art Center building. These works— by Ferber, Nevelson, Westerlund Roosen, Witkin, Wotruba, and others—have generally been received as gifts and are intended to complement and support the outdoor collection. And such gaps as exist in the primary collection, while they may eventually be filled, are in the meantime resolved by short- or long-term loans. In the summer of 1984, for example, a large group of sculptures was borrowed from the Metropolitan Museum of Art. Among them was David Smith's stainless steel *Becca* (1965), one of his last—and largest— sculptures, which will remain for an indefinite period at the Art Center.

Despite its diversity, one aspect of the collection currently stands out: the group of abstract, direct metal sculptures. They are greatest in number of any type of work in the collection and, for the most part, the largest in scale. Together they stand as a revelation of a particular historical moment, that when the modernist

sculptural monument came of age. Although this group of sculptures now seems to be the special strength of the Storm King collection, one must bear in mind that it is still very much in the process of formation. This is a young institution, still actively collecting. The forms of sculpture will undoubtedly evolve; the collection is certain to evolve with them in the Art Center's continuing effort to showcase the finest recent sculpture.

LEFT TO RIGHT:
Isamu Noguchi
Momo Taro, detail

David Smith
Becca, 1965
Stainless steel, 113¼″ × 123″ × 30½″

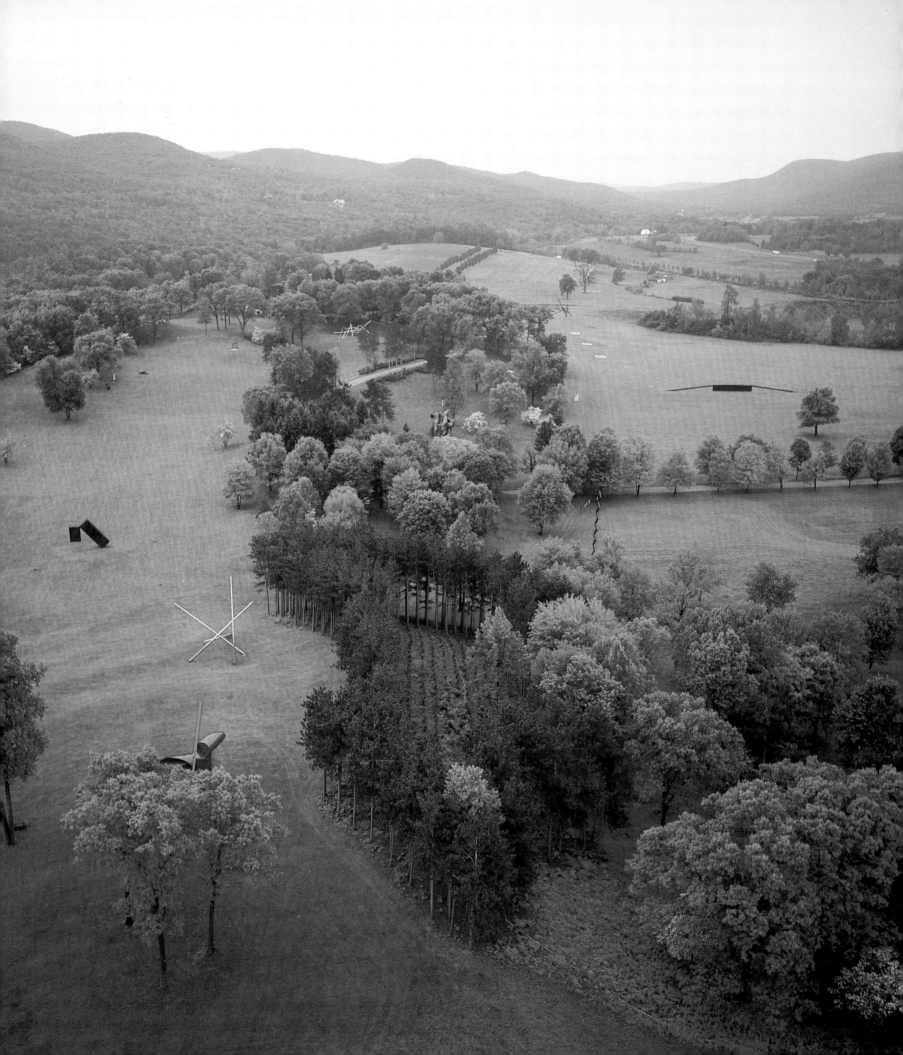

THE LANDSCAPE

Looking at the Storm King landscape today, one might never guess its past. It takes a conversation with landscape architect William A. Rutherford, who has been working with the Art Center for all of its twenty-five years, to learn that the grounds have not always appeared so well composed. When Rutherford first saw Storm King, the west hill, which slopes down to the meadow that shelters the Robert Grosvenor *Untitled* and the von Schlegell "cubes," was a vertical wall over a hundred feet in height. It overlooked a cavernous gravel pit excavated during construction of the New York State Thruway, which passes just to the west of the Art Center. Perhaps to obscure this view, the grounds around the house were thickly planted and overgrown. Immediately adjacent to the building was a formal garden. To the north, now another broad meadow, lay thick woods and a swamp. The principal entrance took a visitor past more low, wet ground to the left and the gravel quarry about one hundred fifty feet to the right.

It has been Rutherford's task to redesign this landscape in concordance with the evolving goals of the Art Center. As the collection has grown, both in the number and scale of its works, so has his job. While responsibility for the selection and siting of sculptures remains with the Art Center's director and board of trustees, Rutherford has advised them regarding appropriate grade, drainage, and proximity to trees, for example. But more importantly, it has been his responsibility to shape the landscape into a coherent whole, to create a unified setting for these works of diverse styles and dimensions while elaborating the considerable variety of contour and vegetation that is the strength of the Storm King landscape.

Rutherford's work began to the west. The gravel pit was filled and the meadow planted. The hill leading up to the house was recontoured and planted with copses of trees and rhododendrons. Over a period of years the dense vegetation around the house was pruned and selectively thinned, and the formal garden was removed. The lawns on the east side of the house were extended and a stone terrace added. Gradually, the

north woods were cleared, the swamp drained, and the present meadow created. Rutherford describes the Storm King landscape as "a growing thing"; indeed, work is still underway on several major portions of it. To the south and east, the steep slope that falls away from the house is receiving new grass ramps and terraces, which will make the hill easier to climb and add new spaces for sculpture. And to the west, the last remaining part of the gravel quarry is scheduled to be reclaimed and converted into an auxiliary parking area.

Several general conceptions govern this shaping of Storm King. Rutherford prefers the appearance of naturalness to that of formality; that is why he removed the rigidly geometric garden near the house. It was his sense that a formal landscape would compete with the sculpture, while a landscape of curves, of seemingly random plantings, and of contrasting open and intimate spaces would receive the sculpture more graciously. Certainly the variety of settings that he has established allows for an equal variety in sculptural types: small pieces that reward care-

ABOVE:

Gilbert Hawkins
Four Poles and Light, 1973
Aluminum, 50′ × 50′ × 50′

RIGHT:

Menashe Kadishman
Eight Positive Trees, 1977
Cor-ten steel, trees range in height
from 8′ to 12′

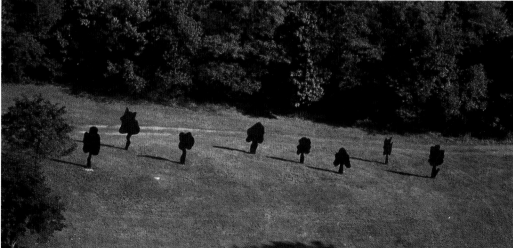

ful scrutiny are clustered around the house, many of them in special niches in the shrubbery, while sculptures that benefit from being seen at a distance as well as in close proximity are stationed in the far meadows; still others can be discovered in the distant woods.

Consistent with this goal of naturalness is Rutherford's notion that he should provide a subtle circulation pattern that encourages people to wander without feeling that they are being maneuvered in a prescribed manner. Ramps and terraces prompt exploration in one direction, while vistas beckon in another. "Every time you turn a corner," he adds, "you should be surprised." You should see a change of scale or contour, or a new kind of setting for sculpture. Above all, you should not feel that the sculpture has been "plopped down, but melded together" with the site, through the proper design of both the general and particular aspects of the landscape. He describes Storm King as "one big overall sculpture into which you add other sculptures."

In its emphasis on naturalness

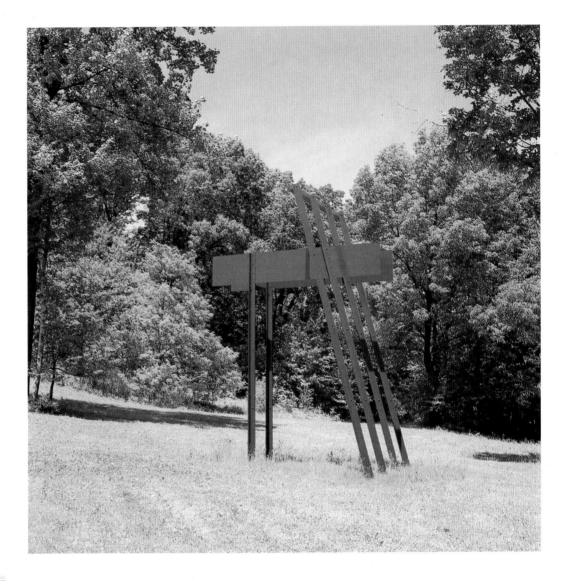

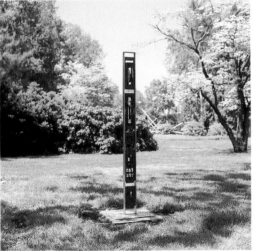

ABOVE:
Lyman Kipp
Lockport, 1977
Aluminum (painted blue), 18′ × 12′ × 10′6″

LEFT:
Dorothy Dehner
Cenotaph IV, 1972
Aluminum and bronze, 75½″ × 5¾″ × 5¾″

and on unified variety, Rutherford's work at Storm King is in the long and distinguished tradition of the picturesque park, which reached its apogee in this country with the work of Frederic Law Olmsted and Calvert Vaux, designers of Central Park in Manhattan and Prospect Park in Brooklyn. Storm King shares with these parks the spirit of surprise, informality, and multiplicity, but it may relate even more closely to Olmsted and Vaux's antecedents, the landscaped parks of eighteenth-century England. These picturesque landscapes, such as

Stourhead or Kew Gardens, included built elements—grottoes, temples, cottages, even sham castles and ruins—that were unified visually and sometimes thematically. Storm King substitutes sculpture for these earlier constructions, but the premise is similar: the elements are intriguing in their own right as well as parts of a larger whole.

Yet nowhere does the whole overwhelm the parts, for great care is taken in the placement of individual works. Kenneth Snelson's *Free Ride Home*, acquired in 1975 from an ex-

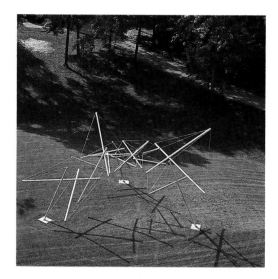

hibition of the artist's work at Waterside Plaza on East River Drive in New York, provides a case in point. Composed of long aluminum tubes held in tense equilibrium by slender cables, this is a complex yet delicate structure, and one that requires some amount of visual shelter. An excellent site was found for it at Storm King within a wide, tree-lined curve of the driveway that climbs up to the Art Center building. Here it stands out against the slope and the greenery behind it. But because the site is lower than much of the surrounding ground, the grade was altered to create a small rise in the center of the glade, which serves as a springboard for Snelson's arcing forms. Three concrete footings were set into the low mound to secure the only elements of this elaborate sculpture that touch the ground.

Similar effort went into the placement of Noguchi's *Momo Taro*. Noguchi wanted the site higher and broader, since part of the purpose of the commission was to provide a place of repose and a vantage point overlooking other areas of the Art Center. At the top of the hill a low mound

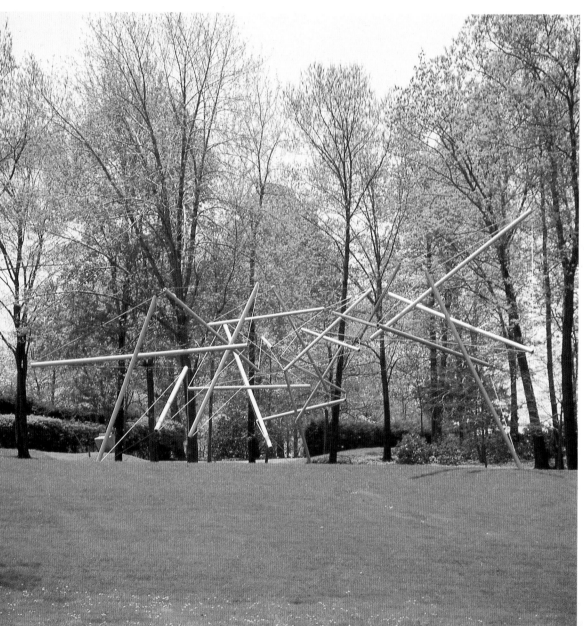

was added, with dry stone wells built to surround and protect the bases of adjacent trees that were now below grade. Noguchi's sculpture comprises over forty tons of granite, so an elaborate concrete platform was buried in this hill, with smaller vertical pedestals set to receive the individual elements. The carved stones were shipped from Japan, loaded on a container truck, and hoisted into position at Storm King with an eighty-foot boom crane. As was planned, all this hard labor helped create an effect of easy grace. The rounded stones stand at the crest of the hill, while the horizontal ones fall away, hugging the contours of the receding ground.

It is not only advance planning that enables these sculptures to sit so comfortably in their respective sites. In the early years of the Art Center, the difficulties of mowing close to the sculptures required that all of them be elevated on obtrusive concrete platforms. The development of the humble nylon grass whip changed all that: the grass could now be cut right up against the sculptures without damage to them, removing the necessity for an unsightly barrier between sculpture and landscape. Indeed, though the original responsibility for sensitive placement of sculpture lies with the Art Center's officers, aided by its landscape architect, it is the groundskeepers who insure that everything continues to look well cared for. The satisfying appearance of Storm King is thus the outcome of much effort on the part of many people: it could not be what it is without all the participants.

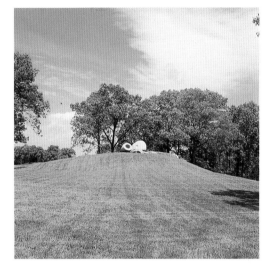

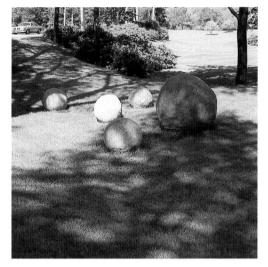

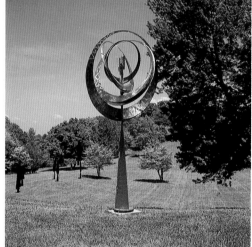

OPPOSITE:
Kenneth Snelson
Free Ride Home, 1974, two views
Aluminum and stainless steel, 30′ × 60′ × 60′

ABOVE, CLOCKWISE FROM UPPER LEFT:
Isamu Noguchi
Momo Taro, 1977
Granite, 9′ × 35′2″ × 22′8″

Grace F. Knowlton
Spheres, 1973–75
Concrete, diameter of large sphere: 96″;
diameter of small spheres: 36″

Jerome Kirk
Orbit, 1972
Stainless steel, 12′ × 6′ × 6′

Forrest Myers
Four Corners, 1969–70
Brass, stainless steel, Cor-ten steel,
and concrete, 120″ × 120″ × 120″

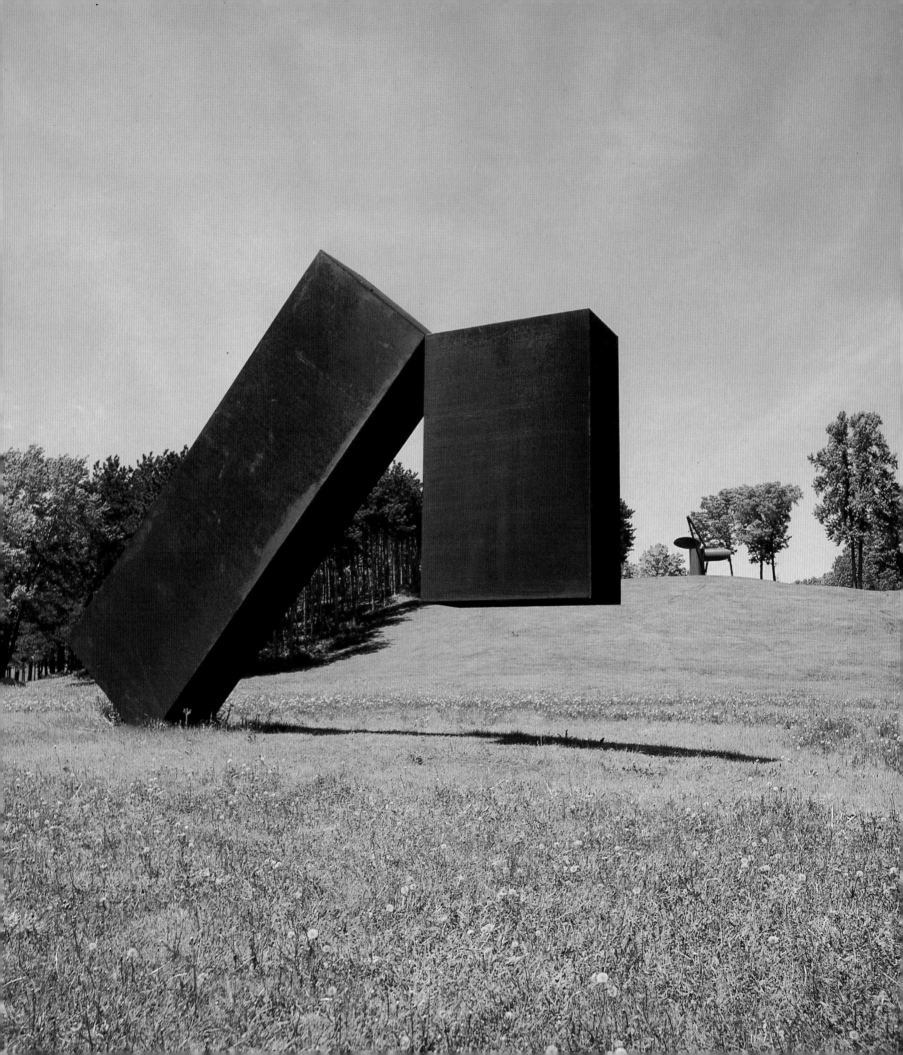

EQUILIBRIUM

Why is it that we find Storm King so satisfying? It is, to be sure, a beautiful landscape, and the collection includes some remarkable sculptures. But this whole is decidedly greater than the sum of its parts. Some magic is worked, the means of which are not immediately evident. It may be that they can never be entirely known or described, in the sense that most exalted artistic experiences remain somewhat ineffable. Yet we can hope for clues.

As the pivot on which much of the collection turns and as perhaps the single most important inspiration for the Art Center, we look first to David Smith. Why did he put his sculpture outdoors? There were certainly practical reasons. Smith was remarkably prolific in his later years, the same years in which his work attained its maximum size. Compounding the storage problems that this could be expected to cause was a tendency already noted to hoard his sculpture. "The work is my identity," he stated flatly.[19] Several letters attest to the strength of his possessiveness: he insisted on keeping his sculpture around him, planted in the fields at

Bolton Landing.[20] "I put my work in the fields," Smith recalled in 1962. "That was an emergency, lacking storage space."

"I did not conceive a field complex," Smith insisted in the same statement, "but since it grew of necessity I accept it."[21] If the first placements of sculpture outdoors at Bolton Landing were random, this soon changed. By the early 1960s Smith was arranging these works with a deliberation that transcended mere utilization of convenient storage space. Sculptures were placed on specially constructed bases in rows on either side of the driveway that led up to his house. In the field to the south they were arranged on a north-south axis; to the north, east and west. There were some practical advantages to this outdoor installation: Smith could compare his works to each other, study together those in a series, and take time to evaluate the individual works. "When [a sculpture] is finished," Smith explained, "there is always that time when I am not sure . . . I have to keep it around for months to become acquainted with it . . . and as I work on other pieces and look at it

Menashe Kadishman
Suspended, 1977
Cor-ten steel, 23' × 33'

all the kinship returns, the battle of arriving, its relationship to the preceding work and its relationship to the new piece I am working on. Now comes the time when I feel very sure of it, that it is as it must be and I am ready to show it to others and be proud I made it."[22] In addition, Smith liked to test his sculptures with a period of weathering outdoors. He was very proud of the way his pieces were painted: "about three times the paint coat on a Mercedes or about thirty times the paint coat on a Ford or Chevrolet," he boasted.[23] But he

noted that if the unpainted stainless steel he also used was scratched in shipping, the consequent rusty streaks would not show up for some time. "I have to leave it out of doors for a while to see if there are any contaminative rust spots on it, and then grind them off later."

There are, however, numerous clues that Smith's inclination to place his sculptures outdoors was not entirely guided by pragmatism, even at the outset. Long before he began installing the sculptures in his fields, he had been photographing them

against the Bolton Landing landscape. Nor was this entirely a matter of convenience, of exploiting available light, for he consistently used two particular compositional formats: he would photograph the sculptures from slightly below and at close range, with the horizon line at the midpoint of the sculpture or lower, or he would take the sculptures down to the pier at Lake George and photograph them from the same perspective against the lake and the hills beyond.[24] In either case, these images stressed the monumentality

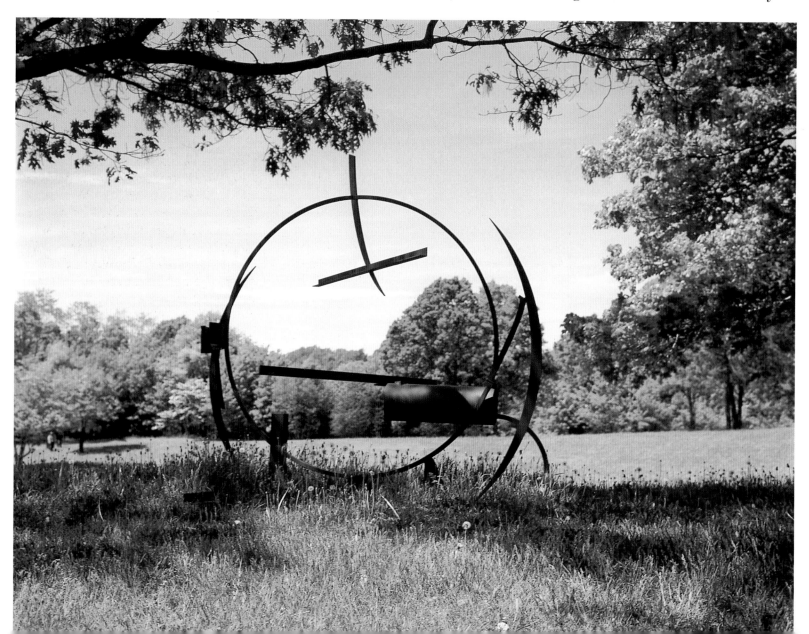

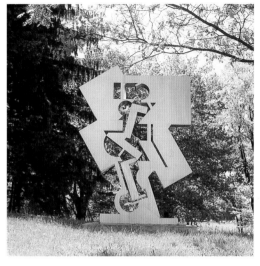

of the sculptures, exaggerating their height and thinness. It was as if Smith were putting them up against the only other element in his world as rugged and expansive as they were and calling the contest a draw by the choice of camera angles. The same impulse that determined his photographic conventions must have guided his placement of sculpture outdoors.

"It was a necessity initially," recalls Dan Budnik, a photographer who was a friend of Smith's and a periodic visitor at Bolton Landing. "But he began looking at the fields as a work of art. By a certain point, he was working for the outdoors." Smith himself noted that his stainless steel sculptures almost require the outdoors. "They are conceived for bright light, preferably the sun, to develop the illusion of surface and depth."[25] Describing a photograph of one of these pieces, he said, "This is the only time—in these stainless steel pieces—that I have ever been able to utilize light, and I depend a great deal on the reflective power of light. In this case, it is late afternoon, and there is a sort of golden color re-flected by the late afternoon sun in the winter . . . and when the sky is blue, there is a blue cast to it."[26] He made a similarly satisfied observation to art critic Thomas Hess: "on a dull day, they take on the dull blue, or the color of the sky in the late afternoon sun, the glow, golden like the rays, the colors of nature."[27] If only the stainless steel works actually require the outdoors, virtually all the sculptures benefit from it, for it is only in a truly expansive setting that all the ambition, exuberance, and drama of these pieces are fully released. As Budnik expresses it, the difference between a Smith sculpture outdoors and one in a museum is "like an animal in the wild versus an animal in a zoo."

The satisfactions that Smith experienced by installing his sculptures outdoors are similar in many respects to those we sense at Storm King. As Ralph Ogden observed, the landscapes of Bolton Landing and Mountainville are much alike, but the parallels are deeper. Smith found in the open air a space sufficiently grand to accommodate his expansive works; this is equally a feature of Storm King.

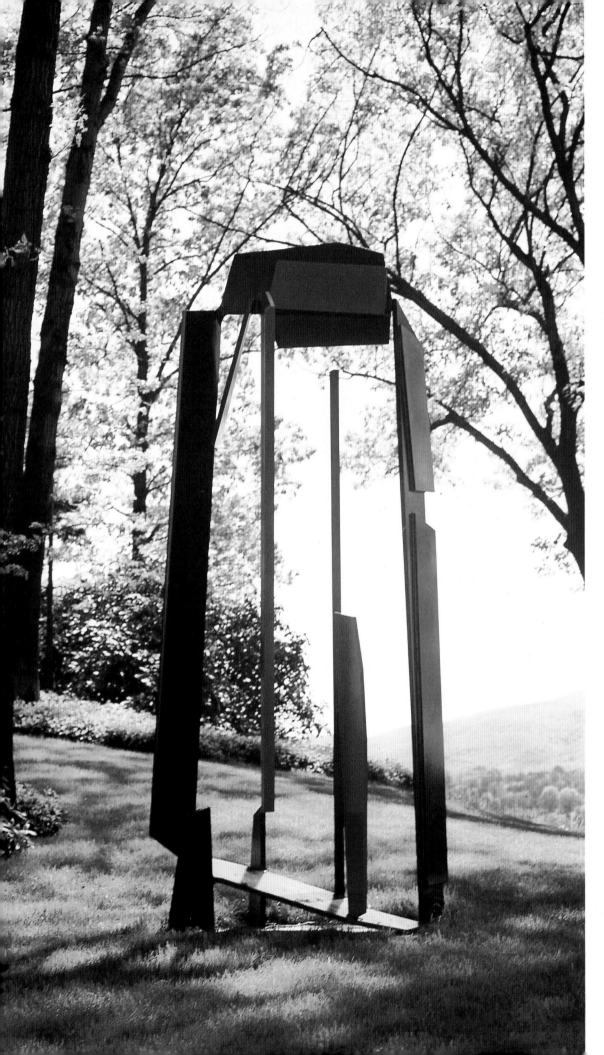

The thoughtfulness with which he worked at installation also characterizes the Art Center's approach: through their careful orchestration, one can evaluate individual works, compare them to each other, and even study them in series, as with the di Suveros. The generous scale of Storm King facilitates this process of exploration. As Trustee Cynthia Polsky notes, "people need time and space to reflect and absorb." At Storm King, as at Bolton Landing, each of us fights Smith's "battle of arriving," coming to know and finally to evaluate the individual and collected works.

Perhaps the most important similarity between Bolton Landing and Storm King, however, is in the kind of liberation that is attained by sculptures—particularly large ones—in the landscape: witness Budnik's analogy to animals. This liberation is literal—again, the matter of space—and figurative. The grand gestures of a Calder or a di Suvero or a Snelson, to name but a few, are best revealed when our vision is unconstrained, passing directly from them to the immoderate mountains and sky. To di Suvero, this is a "gorgeous union," one of "opening out in scale with the surroundings." Noguchi is equally enthusiastic. "I knew of no other place like it—the sense of space, of horizons, the consciousness of sky."

LEFT TO RIGHT:
Joel Perlman
Night Traveler, 1977
Steel (painted black and brown),
10'11" × 4'3" × 5'

Tal Streeter
Endless Column, 1968, two views
Steel (painted red), 62'7" × 6' × 7¼"

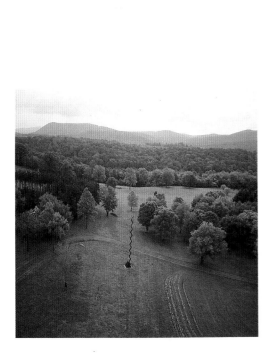

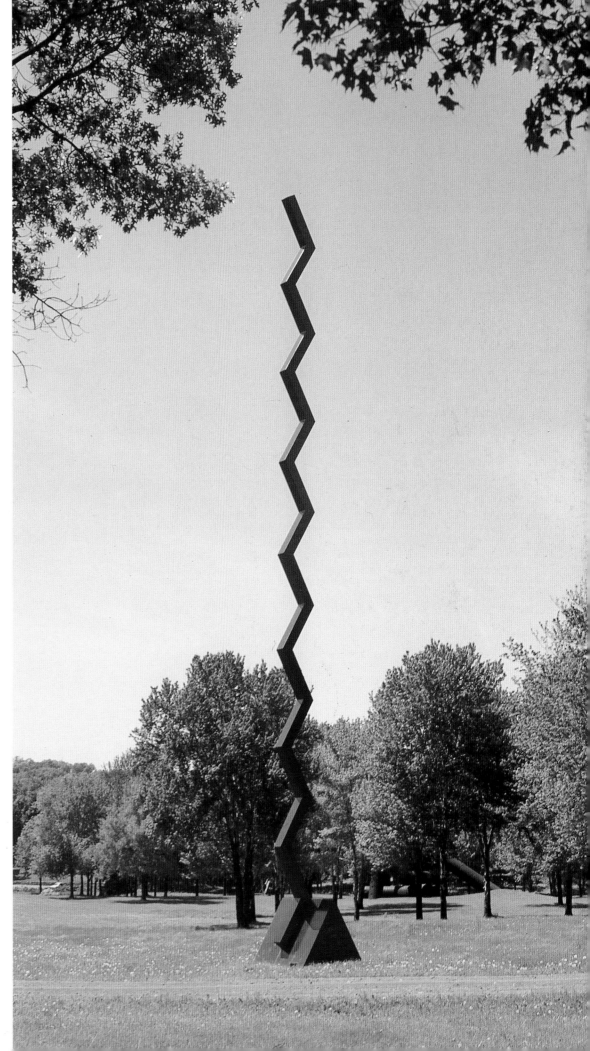

As noted before, Noguchi worked directly with this consciousness of the Storm King landscape in creating his hilltop sculpture *Momo Taro*. Other artists have had the same opportunity. In the early 1970s David von Schlegell was commissioned to produce a piece for the west field. There are two major features of this site: the broad, mostly level expanse of the field itself and the steep grade of the hill behind. Likewise, there are two primary views of it: one from the driveway upon entering Storm King, the other looking down from the parking area in front of the Art Center building. It was with these features in mind that von Schlegell conceived his three floating rectangles. He explains that he wanted to work with both the plane and the hill, and stationed his sculpture just at their intersection. The legs were designed to be as thin as possible to make the rectangles appear to hover as you pass along the driveway. From above, as von Schlegell observes, the rectangles seem instead to be resting directly on the ground, unless the sun is bright, when the elements rise up once more against their shadows. While he was very aware of the features of his Storm King site, von Schlegell was also thinking of other landscapes while creating this piece. He likens his rectangles to the abstract, almost calligraphic brushstrokes in some Chinese paintings and to the faceted forms of a Cézanne landscape. Like these, he describes his work as "a geometric mark in nature." He also notes a more surreal effect: standing under the rectangles, they look like clouds that are light at the center and dark at the edges, in a reversal of the usual pattern.

CLOCKWISE FROM RIGHT:
David von Schlegell
Untitled, 1969
Stainless steel, vertical element: 96¼″ × 116″ × 13¼″; horizontal element: 5′4″ × 81′ × 4′4″

Untitled, 1972, two views
Aluminum and stainless steel, three elements, 20′ × 304′ × 16′ overall

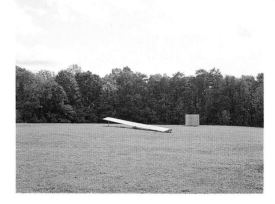

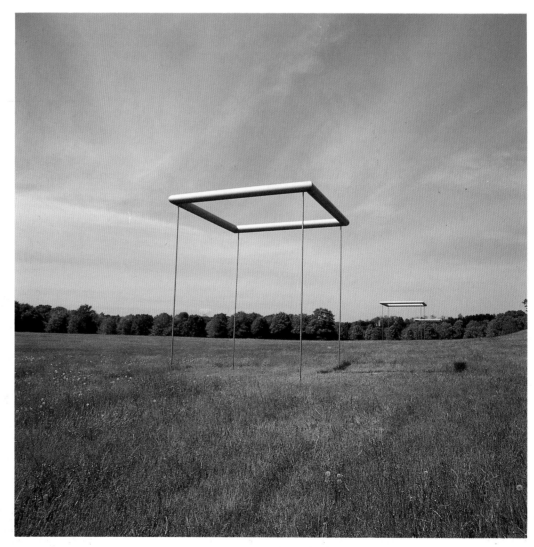

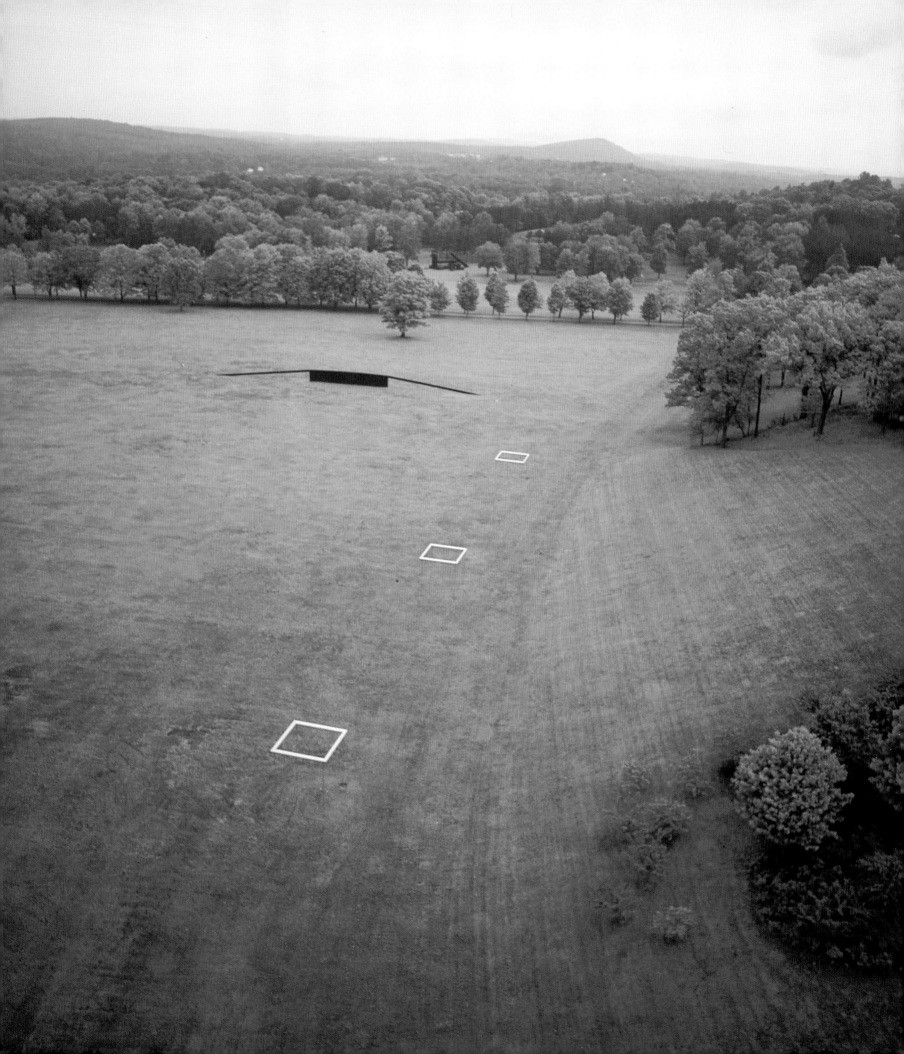

Robert Grosvenor
Untitled, 1974, two views
Cor-ten steel (painted black), 9′ ×
204′ × 18″

Robert Grosvenor's *Untitled* (1974) was also created in response to the Art Center's distinctive landscape. Long and low, its proportions were generated by the great breadth of the west field, while its silhouette is like the mountains beyond. This work is enormous—nine feet high and over two hundred feet long—but restrained, taking on the vast scale of its setting yet remaining almost humble in its formal simplicity. Like the Noguchi and the von Schlegell, it exemplifies the tendency among certain recent sculptors to work in a mode that has been described as environmental. Because the work is made for a particular site, rather than simply set down upon it, the sculpture establishes a strong visual dialogue with its surroundings. The landscape becomes almost a part of the work. This call and response between sculpture and environment is one of the signal features of Storm King, achieved with particular effectiveness in these commissioned works.

To some observers, the juxtaposition of large, predominantly machine-made or technologically sophisticated sculptures with so pastoral a landscape is jarring, if not wholly unsatisfying. In a 1980 essay in *Arts Magazine*, writer Emmie Donadio lamented "the disjunction between the rural setting and the fruits of industrial technology" at Storm King, and described the Art Center as "the natural garden setting surrounded, if not devoured, by encroachments of modernism we recognize as inherently un- if not anti-natural."[28] Some of Storm King's artists might agree with her to some degree. Noguchi, for example, describes himself as motivated by a desire to work in a manner that is "compatible with the landscape." While he acknowledges that almost anything an artist does in the landscape could be considered intrusive, he stresses that "when man is involved with nature with a conscience, then you have a poetic view. You're not just taking something over." He notes that "primitive people had no way to destroy the landscape. We do. It can go to people's heads." "It's a question of responsibility," Noguchi continues. "What is art but a certain restraint, a certain responsibility? Artists should be restricted by modesty." Noguchi's notion of the poetic view, of working responsibly, informs his own work at Storm King, particularly in his choice of material and technique. He prizes *Momo Taro* for its handmade, even rustic character, as distinct from other sculptures that are industrially fabricated from drawings or small-scale models. These he describes as "not sculpture, but part of the architectural process." And he prides himself on his use of stone, rather than some newer material. "Everything is so transient these days," he complains. "It is a world made for quick disposal." By comparison, he insists, "*Momo Taro* has weight. You can feel it. It is more enduring." These qualities certainly go a long way to making *Momo Taro* one of the sculptures most compatible with the landscape at Storm King.

To other observers the "clash of metaphors" between the modern and the rural that Donadio regrets about Storm King is precisely its virtue. Cynthia Polsky admits to another view, in which one looks beyond superficial dissonance to more profound harmonies. Storm King, she believes, offers "a counterpoint between the abstract forms of nature and the ab-

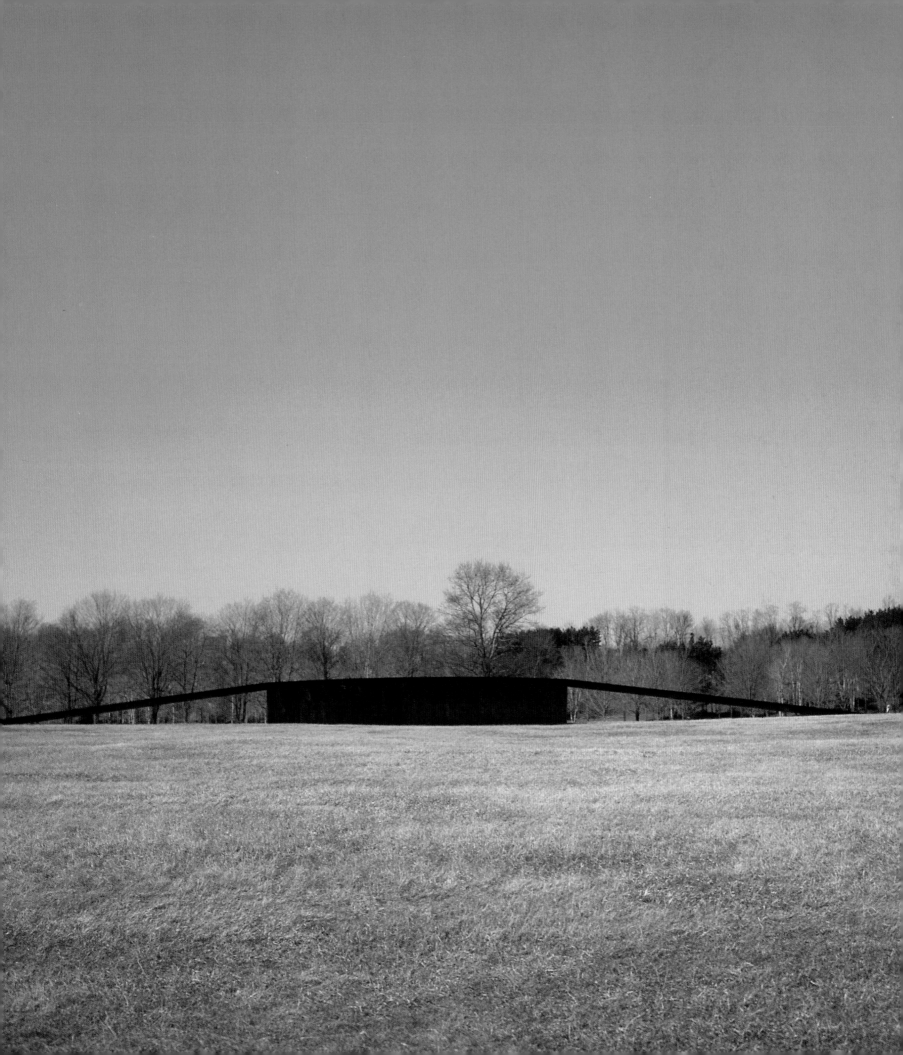

stract forms of sculpture, which are often derived from the landscape." To her this is a relationship of contrast, but not inherent incompatibility, for "abstract work is linked with the landscape through similar forms and rhythms." This is a relationship that holds true whether the material is wood, stone, or steel. It does so in the eyes of di Suvero, who says of the Calder and the Grosvenor at Storm King that "they sing with the landscape, though they are different from each other and from the landscape."

Di Suvero compares Storm King to Asher B. Durand's painting *Kindred Spirits* (1849), in which two men contemplate a waterfall in the mountains. "We're standing on the edge of the falls," he notes, "but we're looking out on art rather than nature." Art and the waterfall are thus linked in his mind: both become the objects of rapture. His remark provides a clue to one of the deeper satisfactions of the Art Center. Cohabiting at Storm King are two of the most potent myths of the American imagination: the machine and the natural paradise. Both myths have venerable traditions in American arts and let-

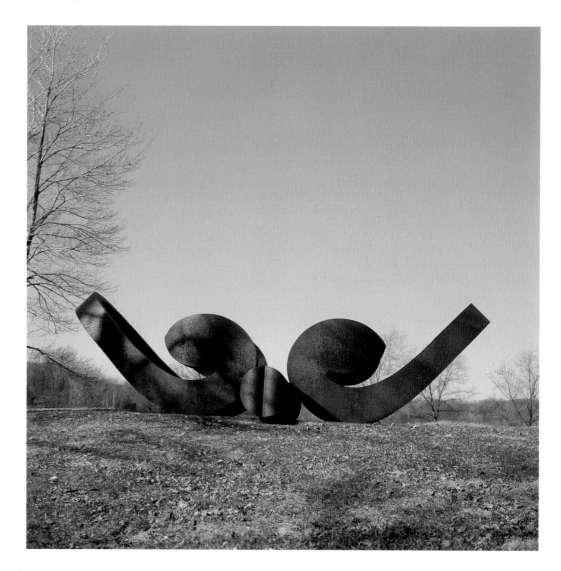

ters.[29] Suffice it to say here that the appreciation of landscape in the United States long ago approached the status of an unofficial religion, in which the Divine was immanent in nature. At the same time, our enthusiasm for the landscape has been matched by a virtually boundless technological optimism. Only recently has our romance with the products of industry and science begun to cool; still, with some notable exceptions, we remain helplessly enthralled and much the better for it. These myths are generally relegated to their respective spheres: remote countryside for the transcendental landscape; urban sprawl for the wondrous machine. Their joint appearance at Storm King may be unsettling, but it is provocatively appropriate.

No sculpture in the Storm King collection resembles a machine; indeed, many have a lyrical, anecdotal, or even erotic significance, not to mention a formal character, that runs counter to any kind of machine- or space-age look. But many—I refer principally to the direct metal sculptures—are composed of the products of the factory and assembled by the most sophisticated techniques. As is the case with many modernist works, the technique here is part, though not all, of the content: these sculptures signify the very same technological advancement that makes them possible. These machine-made giants thus clash with the landscape only in superficial aspect. Just as their forms can be seen to echo the natural surroundings, so do they aspire to evoke the same kind of exalted emotion we associate with the majestic setting. They do this through their scale, to be sure, but also through their reference to a myth of technology every bit as powerful and pervasive as that of the landscape. These myths are not synonymous; they do not converge: they are compatible instead in their magnitude and their hold on our imaginations. Storm King commits them to a respectful truce.

As in David Smith's photographs, then, the exemplars of modernity at Storm King stand at ease in their worthy surroundings. It remains to be seen if the equilibrium arranged here between the veneration of the landscape and the infatuation with technology will ever be achieved in the wider context of our culture. It is a volatile equation, to be sure, but one that is held in balance at Storm King through the well-tuned sensibilities of all concerned. Together they have created one of the few truly satisfactory homes for postwar sculpture, a place that fully admits to the independence of this sculpture from other things, yet provides it with the heroic setting it needs to take the measure of its own strength.

Gerald Walburg
Loops V, 1971–72
Cor-ten steel, 4′7″ × 16′7″ × 9′5″

Notes

Full references for works cited in shortened form appear in the bibliography.

1. The phenomenon of sculpture *in* the landscape is somewhat different from that of sculpture *as* landscape (or vice versa), as in earthworks or environmental art. See my book *Earthworks and Beyond* (New York: Abbeville Press, 1984).

2. Recently, however, a number of important sculptors, including Siah Armajani, Scott Burton, and Nancy Holt, have taken steps to reverse this dominance, reintroducing historical or commemorative content into their work and attempting to reconcile it with architecture. Some have termed this sculpture *post-modern*, with the idea that it signals the beginning of a new era.

3. For a good survey of museum gardens, sculpture parks, and ancient sculpture sites, see Sidney Lawrence and George Foy, *Music in Stone* (New York: Scala Books, 1984).

4. Quoted in Eugenia S. Robbins, "The Storm King Art Center," p. 109.

5. Unless otherwise noted, all quotations are taken from conversations with the author.

6. Quoted in Robbins, "Storm King," p. 109.

7. Grace Glueck, "13 Smith Works Find New Home," p. 28.

8. These figures are drawn from E. A. Carmean, Jr., *David Smith* (Washington,
D.C.: National Gallery of Art, 1982), p. 54.

9. Quoted in Robbins, "Storm King," p. 109.

10. Quoted in Glueck, "Smith Works," p. 28.

11. From a brief autobiography written about 1950 and published in Cleve Gray, ed., *David Smith by David Smith* (New York: Holt, Rinehart and Winston, 1968), p. 25.

12. Quoted in Garnett McCoy, *David Smith* (New York: Praeger Publishers, 1973), pp. 118–19.

13. This is a notion developed in great depth in Rosalind Krauss, *Terminal Iron Works: The Sculpture of David Smith* (Cambridge: M.I.T. Press, 1971).

14. Quoted in Gene Baro, "Some Late Words from David Smith," *Art International* 9 (October 1965): 50.

15. Quoted in Rosalind Krauss, *The Sculpture of David Smith: A Catalogue Raisonné* (New York and London: Garland Publishing, 1977), p. 85.

16. This story appears frequently in the Calder literature. This version is taken from H. H. Arnason, *History of Modern Art* (Englewood Cliffs, N.J.: Prentice-Hall, and New York: Abrams, 1968), pp. 397–98.

17. Quoted in Barbara Rose, *Alexander Liberman* (New York: Abbeville Press, 1981), p. 327.

18. Isamu Noguchi, *A Sculptor's World* (New York: Harper and Row, 1968), p. 159.
19. Quoted in Krauss, *Terminal Iron Works*, p. 60.

20. These letters are cited by Krauss in ibid., p. 60, n. 14.

21. Quoted in McCoy, *Smith*, p. 162.

22. Quoted in Gray, *Smith*, p. 57.

23. Quoted in Baro, "Late Words," p. 49.

24. Smith's photographic conventions are discussed in Carmean, *Smith*, pp. 55–56.

25. David Smith, "Notes on My Work," *Arts Magazine* 34 (February 1960): 44.

26. Quoted in Baro, "Late Words," p. 49.

27. Quoted in McCoy, *Smith*, p. 184.

28. Emmie Donadio, "Unnatural Appearances: Reflections on Scale at Storm King Mountain," p. 143.

29. Much has been written on both these subjects. On the sanctity of landscape and its impact on nineteenth-century American painting, see especially Barbara Novak, *Nature and Culture* (New York: Oxford University Press, 1980). On the intrusion of technology into the natural paradise, particularly as revealed in nineteenth-century literature, see the pioneering study by Leo Marx, *The Machine in the Garden* (New York: Oxford University Press, 1964). Perry Miller examines a more recent and more ambivalent attitude toward technology in the title essay of *The Responsibility of Mind in a Civilization of Machines* (Amherst: University of Massachusetts Press, 1979), pp. 195–213.

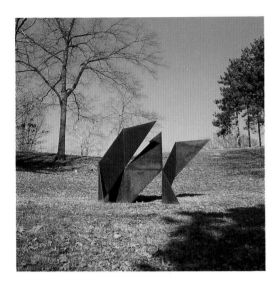

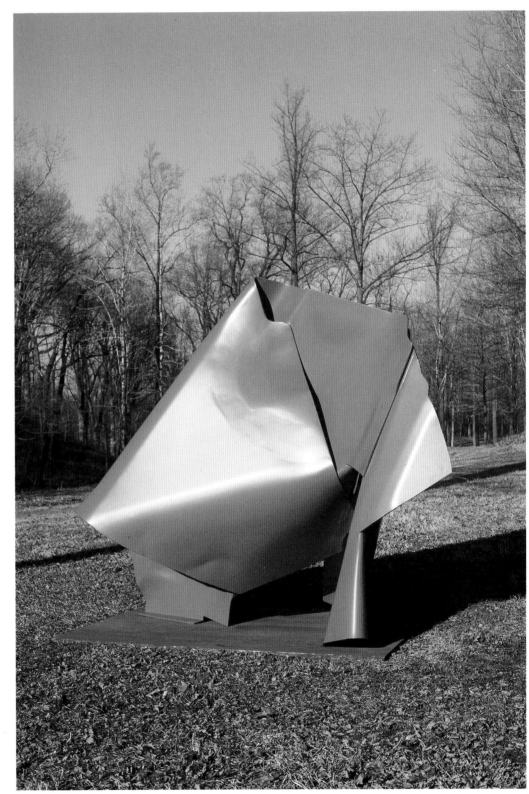

CLOCKWISE FROM UPPER LEFT:

Charles Ginnever
Prospect Mountain Project, 1979
Cor-ten steel, 8′ × 14′ × 8′

Robert Murray
Kiana, 1978
Aluminum (painted sienna), 71″
× 47″ × 86″

Jim Huntington
Inheritor (For Jake), 1978
Steel and granite, 83″ × 85″ × 65″

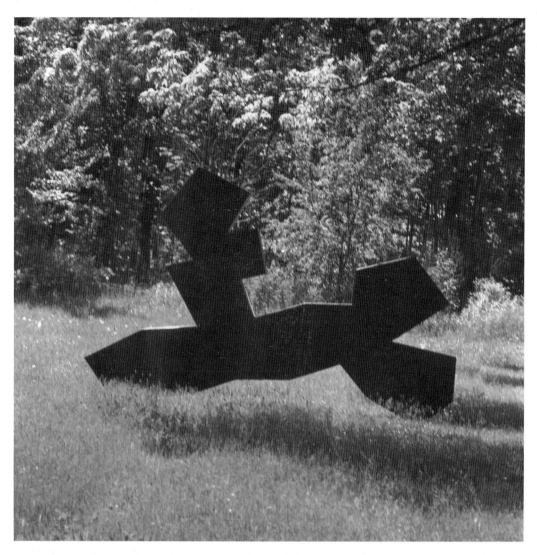

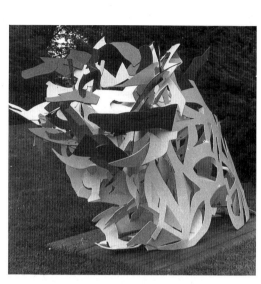

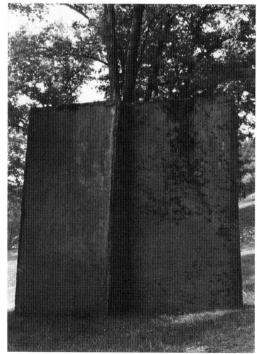

CLOCKWISE FROM ABOVE:

Douglas Abdell
Caephae-Aekyad #2, 1980
Steel (painted black), 8′ × 12′9″ × 2′

George Sugarman
One, 1975–77
Aluminum with enamel paint,
78″ × 84″ × 72″

Mia Westerlund Roosen
Muro Series X, 1979
Black-pigmented concrete and steel
plate, 60″ × 120″ × 40″

OPPOSITE:

Saul Baizerman
Aphrodite, 1940–49
Hammered copper, 18″ × 96″ × 34″

ARTISTS' BIOGRAPHIES

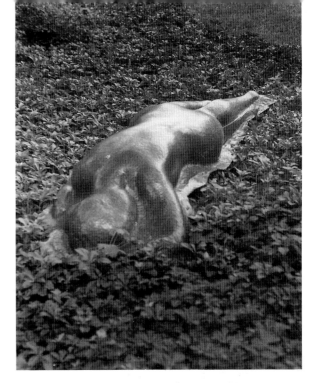

All sculptures are in the permanent collection of the Storm King Art Center, except as noted. The acquisition number included in the credit line indicates the year that the work entered the Storm King collection. Measurements appear in the following order: height × width × depth.

DOUGLAS ABDELL

Born Boston, Massachusetts, 1947

Douglas Abdell received his B.F.A. from Syracuse University in 1970 and the next year was given his first one-man exhibition, at the Graham Gallery in New York. Since then his work has been featured in approximately twenty-five solo shows at the Andrew Crispo Gallery in New York; Storm King Art Center; Amerika Haus in Berlin; Mercato del Sale in Milan, and many other galleries, as well as several colleges and universities throughout the United States. Abdell's sculpture is represented in several permanent collections, including the Outdoor Sculpture Collection of the City of New York, Brooklyn Museum, Corcoran Gallery of Art, Fogg Art Museum, Atlantic Richfield Corporation, and Thyssen-Bornemisza Collection.

Caephae-Aekyad #2, 1980
Steel (painted black), 8′ × 12′9″ × 2′
Anonymous gift, 1981.19
See page 94

SAUL BAIZERMAN

Born Vitebsk, Russia, 1889
Died New York City, New York, 1957

Saul Baizerman attended the Imperial Art School in Odessa before emigrating to America in 1910. He was enrolled at the Beaux-Arts Institute of Design in New York as its first sculpture student (1911–

20), after which he began his City and the People series in hammered bronze. In 1933 Baizerman had his first one-man exhibition in the United States, composed of small bronzes from the early 1920s. He then began work on his hammered copper pieces, such as the one in the Storm King collection. From 1934 to 1940 he taught sculpture, drawing, and anatomy at the Baizerman Art School; between 1949 and 1952 he received grants and awards from the Pennsylvania Academy of the Fine Arts and the Guggenheim Foundation. In 1953 the Walker Art Center in Minneapolis presented a retrospective exhibition of his work, which also traveled to Des Moines, San Francisco, and Canada. Baizerman's work is included in the permanent collections of the Hirshhorn Museum and Sculpture Garden, Pennsylvania Academy of the Fine Arts, and the universities of Minnesota, Nebraska, New Mexico, and North Carolina, among others.

Aphrodite, 1940–49
Hammered copper, 18″ × 96″ × 34″
Purchase, 1980.6
See page 95

MAX BILL

Born Winterthur, Switzerland, 1908
Died Berlin, Germany, 1994

Max Bill studied at Zurich's School of Arts and Crafts (1924–27) as well as at the Bauhaus in Dessau, Germany (1927–29). As a

cofounder and dean of the Academy of Form in Ulm (1951–56) and professor of environmental design at the State Institute of Fine Arts in Hamburg (1967–74), he attempted to integrate all the arts: he has worked not only as a sculptor and painter but also as an industrial designer, journalist, architect, and silversmith. Since 1928 Bill has had numerous one-man exhibitions throughout Europe and, during the past twenty years, in the United States as well. He has been the recipient of many awards and honors, among them the Grand Prize for the Swiss pavilion at the 1951 Milan Triennale, the Kandinsky Prize (1949), and the first International Prize for Sculpture at the 1951 São Paulo Bienal. His work has also been honored with major retrospectives at the San Francisco Museum of Modern Art and the Albright-Knox Art Gallery in Buffalo.

Unit of Three Elements, 1965
Black granite, 31″ × 51½″ × 38″
Purchase, 1967.21
See page 96

LOUISE BOURGEOIS

Born Paris, France, 1911

From 1932 to 1938 Louise Bourgeois studied at the Sorbonne, Ecole du Louvre, Ecole des Beaux-Arts, Atelier Bissière, Académie de la Grande Chaumière, and with Fernand Léger. Following her studies she moved to New York, where she

participated in her first group exhibitions, at the Metropolitan Museum of Art and the Museum of Modern Art in 1943. In 1947 her first solo exhibition was held in New York's Norlyst Gallery. Since that time Bourgeois has participated in numerous group exhibitions and has been the subject of approximately eighteen individual shows. She was honored with a retrospective at the Museum of Modern Art (New York) in 1983. Her work is included in the permanent collections of the Museum of Modern Art (New York), Whitney Museum of American Art, Rhode Island School of Design, Detroit Institute of Arts, Portland Museum of Art, Musée d'Art Moderne (Paris), and the National Gallery of Australia in Canberra, among others.

Number Seventy-two (The No March), 1972
Marble, $10'' \times 17' \times 10'$
Purchased with the aid of funds from the National Endowment for the Arts, 1978.2
See page 66

ALEXANDER CALDER

Born Philadelphia, Pennsylvania, 1898
Died New York City, New York, 1976

Calder received a degree in mechanical engineering from Stevens Institute of Technology in 1919. He then attended the Art Students League in New York (1923–25) before spending a year at the Académie de la Grande Chaumière in Paris, where he began giving performances of his miniature circus. In 1926 he had his first one-man show at the Artists' Gallery in New York. Between 1926 and 1985 Calder was the subject of more than 200 solo exhibitions (excluding his early circus performances); these have featured his paintings, wood and wire sculptures, mobiles, drawings, gouaches, jewelry, large stabiles, and lithographs. Calder's work has been exhibited in almost every major European city, as well as in South America and Thailand, and it is included in the permanent collections of over sixty museums, corporations, and educational institutions worldwide. Calder was the recipient of many awards and honors, the subject of numerous films, and executed commissions from major corporations such as CBS and Braniff Airlines.

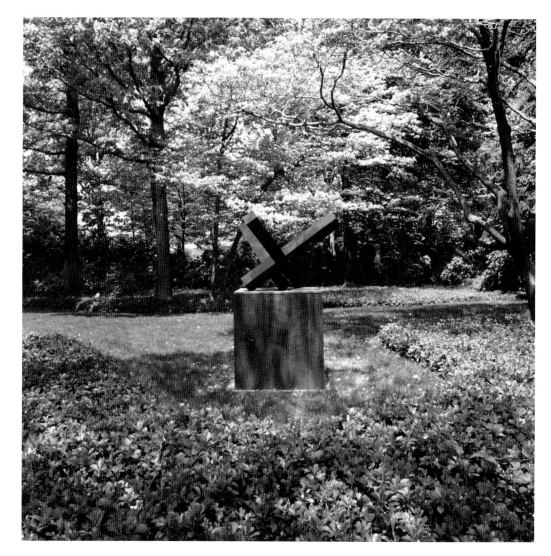

Major retrospectives of the artist's work were held at the Whitney Museum of American Art in 1976 and in Turin in 1983.

The Arch, 1975
Steel (painted black), $56' \times 44' \times 36'$
Purchase, 1982.3
See page 42

ANTHONY CARO

Born London, England, 1924

After studying engineering at Christ's College (Cambridge, 1942–44), Caro went on to study sculpture at London Polytechnic and the Royal Academy of Arts (1946–52). From 1951 to 1953 he worked as an assistant to Henry Moore. He taught at St.

Max Bill
Unit of Three Elements, 1965
Black granite, $31'' \times 51\frac{1}{2}'' \times 38''$

Martin's School of Art in London (1952–53, 1964–73) and Bennington College in Vermont (1963–65). In 1956 Caro had his first one-man exhibition at the Galleria del Naviglio in Milan. Since that time his work has been featured in over sixty solo exhibitions in Belgium, Canada, England, France, Germany, Holland, Italy, Japan, Switzerland, and the United States; in addition, he has been represented in more than 110 group shows. His work is in the permanent collections of numerous museums, including the Museum of Modern Art (New York), National Gallery of Art (Washington, D.C.), Tate Gallery, Arts Council of Great Britain, and Kunsthaus Zurich. In celebration of his sixtieth birthday a four-phase exhibition of Caro's recent sculpture was presented by the Andre Emmerich Gallery, New York, in 1984.

Reel, 1964
Steel (painted red), 34¼″ × 107″ × 37¾″
Purchase, 1970.5
See page 57

Seachange, 1970
Steel (painted gray), 35″ × 111″ × 60″
Purchase, 1971.8
See page 57

DOROTHY DEHNER

Born Cleveland, Ohio, 1901
Died New York City, New York, 1994

Dorothy Dehner studied at UCLA (1920–21) and at the Art Students League (1925–32) with Kimon Nicolaides, Kenneth Hayes Miller, and Jan Matulka. She attended Skidmore College in Saratoga Springs, New York (1951–52), where she received her B.F.A. Until the 1950s Dehner concentrated primarily on painting, but she is also an accomplished sculptor, draftswoman, and printmaker. Since her first solo exhibition at the Albany Institute of Art in 1954, she has received more than fifty one-woman shows, and her work has been exhibited in major museums in the United States as well as in France, Germany, Holland, and the Far East. Solo exhibitions of her work have taken place at the Art Institute of Chicago and at the Jewish Museum, New York, which honored her with a retrospective in 1965. Dehner's works are included

in the permanent collections of the Hirshhorn Museum and Sculpture Garden, Chase Manhattan Bank, E. F. Hutton, New York Public Library, Time-Life, First National Bank (Chicago), and Birla Institute of Art in Calcutta, among others.

Cenotaph IV, 1972
Aluminum and bronze,
75½″ × 5¾″ × 5¾″
Anonymous gift, 1976.4
See page 76

MARK DI SUVERO

Born Shanghai, China, 1933

Mark di Suvero came to the United States in 1941, and from 1953 to 1956 he attended San Francisco City College, California School of Fine Arts, and the University of California at Santa Barbara and at Berkeley. He received his first one-man exhibition at the Green Gallery, New York, in 1960 and has had approximately thirteen solo shows since that time, in the United States, France, the Netherlands, and West Germany. As a participant in group exhibitions, he has shown his work in museums and galleries throughout America, as well as in Belgium, France, Italy, West Germany, Australia, and Canada. The artist was honored with retrospectives at the Whitney Museum of American Art in 1975 and at Oil and Steel Gallery, New York, in 1983. Di Suvero's sculpture is included in the permanent collections of the Hirshhorn Museum and Sculpture Garden, J. B. Speed Art Museum, Walker Art Center, Gilman Paper Company, and Cornell University Art Museum, as well as many private collections. In 1979 he received two National Endowment for the Arts commissions, one for a monumental sculpture at the Inner Harbor in Baltimore and the other for a work in South Bend, Indiana.

Are Years What? (For Marianne Moore), 1967
Steel (painted orange), 40′ × 40′ × 30′
Lent by Oil and Steel Gallery, New York
See page 6

One Oklock, 1968–69
Steel, 28′ × 46′6″ × 39′
Lent by Oil and Steel Gallery, New York
See page 51

Mother Peace, 1970
Steel (painted orange),
39′6″ × 38′5″ × 32′8½″
Purchase, 1981.12
See page 49

Mon Père, Mon Père, 1973–75
Steel, 35′ × 40′ × 40′4″
Purchase, 1981.11
See page 50

HERBERT FERBER

Born New York City, New York, 1906
Died North Egremont, Massachusetts, 1991

Herbert Ferber studied in New York at City College, Columbia University, and the Beaux-Arts Institute of Design (1923–30). His works have been exhibited in more than thirty one-man shows and many group shows since 1937. He has been given retrospectives at Bennington College, Whitney Museum of American Art, Museum of Fine Arts, Houston, and Walker Art Center. His major awards and commissions include a purchase prize from the Metropolitan Museum of Art, the International Sculpture Competition of the Institute of Contemporary Art (London), a Guggenheim Fellowship, and a sculpture commissioned for the John F. Kennedy Federal Office Building in Boston. Ferber's sculptures are part of the permanent collections of the Metropolitan Museum of Art, Museum of Modern Art (New York), National Gallery of Art (Washington, D.C.), Walker Art Center, Rutgers University, Neuberger Museum, and Centre Georges Pompidou. From 1962 to 1967 the artist was visiting professor at the University of Pennsylvania and Rutgers University in New Jersey; in 1979 he held the Mellon Chair as visiting professor at Rice University in Texas.

Konkapot II, 1972
Cor-ten steel, 5′9″ × 4′ × 9′10″
Purchased with the aid of funds from the National Endowment for the Arts, 1975.50
See page 56

RICHARD FRIEDBERG

Born Baltimore, Maryland, 1943

Richard Friedberg attended Antioch College (B.A., 1965) before earning both his

B.F.A. and M.F.A. from Yale University. Currently an associate professor at Fairleigh Dickinson University in New Jersey, Friedberg was given his first solo shows at the Tibor de Nagy Gallery in New York in 1969. His work has since been the subject of several solo exhibitions at the Fischbach and Alexander F. Milliken galleries, both in New York, and has been displayed in group shows at the Whitney Museum of American Art, Corcoran Gallery of Art, Pratt Institute, and Yale University, among others. Friedberg has also received fellowships from the National Endowment for the Arts and the Graham Foundation. Among the institutions that include his work in their permanent collections are Citicorp and Chase Manhattan Bank in New York, Mobil Oil Corporation, and Atlanta International Airport.

Penobscot, 1976
Steel, 8′ × 17′4″ × 14′
Purchased with the aid of funds from the National Endowment for the Arts, 1979.3
See page 99

CHARLES GINNEVER

Born San Mateo, California, 1931

As an art student in Paris, Charles Ginnever studied sculpture with Ossip Zadkine at the Académie de la Grande Chaumière (1953–55) and graphics with Stanley Hayter at Atelier 17 (1955). On his return to America he attended the San Francisco Art Institute (1955–57) and received his M.F.A. from Cornell University in 1959. Since his first one-man exhibition in New York in 1961, Ginnever has had many solo shows, including one at Storm King Art Center in 1980 and a twenty-year retrospective at Sculpture Now, New York, in 1975. He has been the recipient of a San Francisco Art Institute Sculpture Award, a Guggenheim Fellowship, and a grant from the National Endowment for the Arts. Ginnever has executed commissioned sculptures for the St. Paul Courthouse, Walker Art Center, State University of New York at Albany and at Buffalo, the universities of Michigan and Houston, Virlane Foundation in New Orleans, and the Dayton Art Institute, among others.

Fayette: For Charles and Medgar Evers, 1971
Cor-ten steel, 8′4″ × 16′8″ × 18″
Purchase, 1972.1
See page 59

1971, 1971
Cor-ten steel, 42″ × 132″ × 18″
Purchase, 1972.2
See page 83

Prospect Mountain Project, 1979
Cor-ten steel, 8′ × 14′ × 8′
Purchased with the aid of funds from the National Endowment for the Arts, 1979.11
See page 93

EMILIO GRECO

Born Catania, Sicily, 1913
Died Rome, Italy, 1995

Emilio Greco trained as a sculptor in the workshop of a marble mason. While still in the army he joined the Academy in Palermo and later went to Rome, where in 1946 he had his first one-person show at the Cometa Gallery. In 1952 he was professor of sculpture at the Academy of Fine Arts, Carrara. The subject of over twenty-five solo exhibitions throughout Europe and abroad, Greco has received many awards, including the St. Vincent Prize in 1948 and the Medaglia d'Oro del Presidente della Repubblica in 1961. His works are represented in the collections of the Galleria d'Arte Moderna (Milan and Rome), Centre Georges Pompidou, Musée Municipal de Sculpture en Plein Air (Antwerp), Wallraf-Richartz Museum, Tate Gallery, South African National Gallery, Art Gallery of South Australia, and City Art Gallery (Auckland), among others.

The Tall Bather I, 1956
Bronze, 84½″ (including 1½″ base) × 18¼″ × 28″
Purchase, 1963.4
See page 22

ROBERT GROSVENOR

Born New York City, New York, 1937

Robert Grosvenor was educated at the Ecole des Beaux-Arts and the Ecole Supérieure des Arts Décoratifs in Paris and at the Università di Perugia in Italy. Since his first one-man exhibition at New York's Park Place Gallery, Grosvenor's work has been featured in approximately twenty solo shows and more than seventy-five group exhibitions in the United States and abroad. In addition to shows at several galleries in New York, particularly the Paula Cooper Gallery, Grosvenor's work has been exhibited at the New York World's Fair, Jewish Museum, Institute for Contemporary Art (Philadelphia), Whitney Museum of American Art, Rhode Island School of Design, and in Belgium, Denmark, France, Holland, West Germany, Canada, and Australia. He has received grants from the Guggenheim Foundation, the National Endowments for the Arts and for the Humanities, and the American Academy of Arts and Letters. His work can be found in the collections of the Whitney Museum, Museum of Modern Art (New York), Hirshhorn Museum and Sculpture Garden, and Walker Art Center.

Untitled, 1974
Cor-ten steel (painted black), 9′ × 204′ × 18″
Commission, 1974.2
See page 89

GILBERT HAWKINS

Born New York City, New York, 1944

Gilbert Hawkins attended the New School for Social Research and the Art Students League, both in New York City, then earned his B.F.A. from Philadelphia College of Art in 1968. Since that time he has taught and implemented arts programs at secondary schools in New York and New Jersey, as well as at Fairleigh Dickinson University, Sarah Lawrence College, and Pace University. Exhibited primarily in New York, New Jersey, Pennsylvania, and Connecticut, his works are also included in several private collections.

Blue Moon, 1970
Steel (painted blue), 60″ × 22″ × 12″
Purchase, 1973.8

Ex, 1971
Wood and metal, 120″ × 72″ × 20″
Purchase, 1972.19

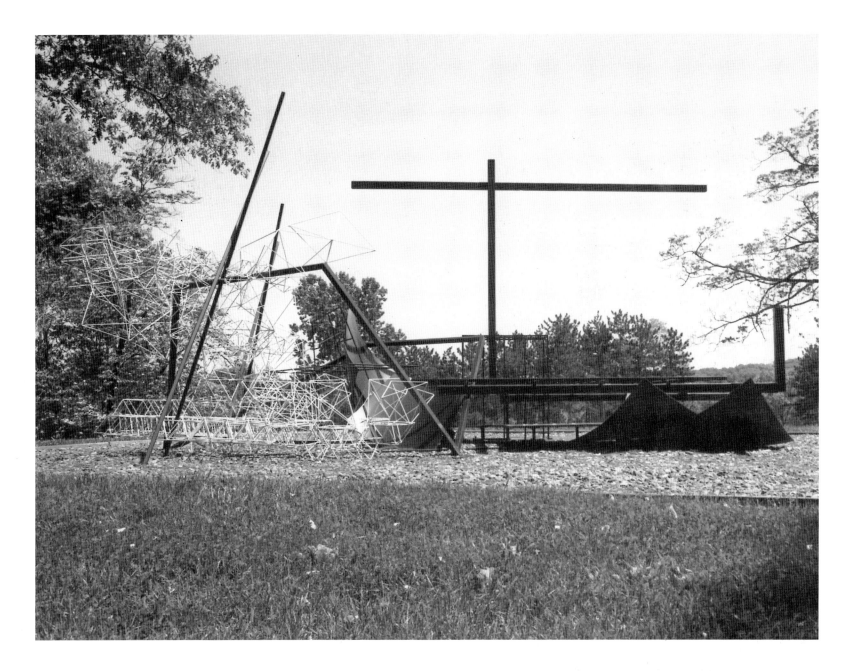

Four Poles and Light, 1973
Aluminum, 50′ × 50′ × 50′
Purchase, 1973.4
See page 76

Richard Friedberg
Penobscot, 1976
Steel, 8′ × 17′4″ × 14′

BARBARA HEPWORTH

Born Wakefield, Yorkshire, England, 1903
Died St. Ives, Cornwall, England, 1975

Barbara Hepworth attended the Leeds School of Art (1919–20) and the Royal College of Art in London (1920–23) before studying in Italy with Ardini from 1924 to 1926. Strongly influenced by the work of Brancusi, she began exhibiting her stone and wood sculptures in group exhibitions in 1928 and was given her first solo exhibition in London in 1937. With Naum Gabo, Adrian Stokes, and Bernard Leach, Hepworth cofounded the Penwith Society of Arts in Cornwall in 1949. Retrospectives of her work have been presented at the Martha Jackson Gallery (New York), Tate Gallery, Moderna Museet (Stockholm), Rijksmuseum Kröller-Müller (Otterlo), and the Hakone Open-Air Museum in Japan. Among Hepworth's commissions is a 1963 memorial to Dag Hammarskjold at the Secretariat Building in New York. Her works may be seen in the permanent collections of the Hirshhorn Museum and Sculpture Garden, National Gallery of Canada (Ottawa), Arts Council of Great Britain, Barbara

Hepworth Museum (St. Ives), and the Art Gallery of Victoria in Melbourne. The recipient of many awards and honors, including Grand Prize at the 1959 São Paulo Bienal and the Foreign Minister's Award at the 1963 Tokyo International Art Exhibition, Hepworth was honored in 1965 with the title Dame Commander of the Order of the British Empire.

Pavan, 1956
Bronze, 29½″ × 43″ × 21″
Purchase, 1968.70

Square Forms with Circles, 1963
Bronze (green patina),
102¼″ × 60½″ × 9⅝″
Purchase, 1969.14
See page 63

JIM HUNTINGTON

Born Elkhart, Indiana, 1941

Jim Huntington attended Indiana University and El Camino College in California (1958–60). He received his first one-man exhibition in Boston in 1964 and has since been featured in many solo shows in New York, Boston, and San Francisco. He has also participated in numerous group exhibitions at institutions such as the Corcoran Gallery of Art, Whitney Museum of American Art, Institute of Contemporary Art (Boston), Storm King Art Center, and Bank of America. His works are in the permanent collections of the Whitney Museum, Chase Manhattan Bank, Massachusetts Institute of Technology, Madison Square Garden Corporation, and Power Institute of Contemporary Art (Sydney), among others.

Inheritor (For Jake), 1978
Steel and granite, 83″ × 85″ × 65″
Gift of Cynthia Hazen Polsky, 1982.4
See page 93

MENASHE KADISHMAN

Born Tel Aviv, Israel, 1932

Menashe Kadishman studied at St. Martin's School of Art, London, and was given his first one-man exhibition in London in 1965. Since then, Kadishman's work has been featured in solo shows at the Jewish Museum and Rina Gallery in New York, Israel Museum and Galerie Sarah Gilat in Jerusalem, the Julie M. and Sarah Levy galleries of Tel Aviv, and other galleries and museums in the United States and abroad. Kadishman has participated in more than thirty group exhibitions and symposia, including the Symposium for European Sculptors (Kirchheim, 1961), the International Sculpture Symposium (Toronto, 1967), the 5th Paris Biennale (1967), the Venice Biennale (1972), and the International Sculpture Symposium (Washington, D.C., 1980).

Suspended, 1977
Cor-ten steel, 23′ × 33′
Lent by the Muriel and Philip Berman Collection
See page 80

Eight Positive Trees, 1977
Cor-ten steel, trees range in height from 8′ to 12′
Lent by the Muriel and Philip Berman Collection
See page 76

LYMAN KIPP

Born Dobbs Ferry, New York, 1929

Lyman Kipp attended Pratt Institute and Cranbrook Academy of Art (1950–54) and taught at Bennington, Pratt, Dartmouth, and Hunter colleges from 1960 to 1968. Since 1954 he has had thirty-four solo exhibitions and participated in numerous group shows. He has been chairman of the art departments of Lehman and Hunter colleges, received both a Guggenheim and a Fulbright Fellowship, and completed a commissioned work for the Federal Office Building and Post Office in Van Nuys, California. Among the many collections that include Kipp's work are the Whitney Museum of American Art, New York Bank for Savings, Massachusetts Institute of Technology, and the High Museum of Art.

Lockport, 1977
Aluminum (painted blue), 18′ × 12′ × 10′6″
Purchased with the aid of funds from the National Endowment for the Arts, 1979.2
See page 77

JEROME KIRK

Born Detroit, Michigan, 1923

Jerome Kirk received his B.S. in 1951 from the Massachusetts Institute of Technology. Kirk's sculpture made its public debut in 1952 and has since been exhibited at the Detroit Institute of Arts, M. H. de Young Museum in San Francisco, and Baltimore Museum of Art, among others. His major sculpture commissions include works for Union Bank Square in Los Angeles, Storm King Art Center, Monterey Cultural Center in California, and two pieces for the Arizona Civic Plaza in Phoenix.

Orbit, 1972
Stainless steel, 12′ × 6′ × 6′
Commission, 1972.10
See page 79

GRACE F. KNOWLTON

Born Buffalo, New York, 1932

Grace Knowlton attended Smith College (B.A., 1954), then went to the Corcoran School of Art and American University in Washington, D.C. She also studied painting with Kenneth Noland and Vaclav Vytlacil, drawing and sculpture with Lothar Brabanski, and steel welding with Martin Chirino. From 1954 to 1957 the artist worked as assistant to the curator of graphic arts at the National Gallery of Art; she taught at the Arlington public schools from 1957 to 1960. In 1981 Knowlton received her M.A. in art and education from Columbia University Teachers College. Her work has been exhibited in both solo and group shows and is included in the permanent collections of the Corcoran Gallery of Art, Metropolitan Museum of Art, and Newark Museum.

Spheres, 1973–75
Concrete, diameter of large sphere: 96″;
diameter of small spheres: 36″
Gift of Grace F. Knowlton, 1977.4
See page 79

SOL LEWITT

Born Hartford, Connecticut, 1928

Sol LeWitt received his B.F.A. from Syracuse University in 1949. He has been an

instructor at the Museum of Modern Art School (1964–67), Cooper Union (1967–68), and New York University (1970). He has been given retrospectives at the San Francisco Museum of Modern Art and the Museum of Modern Art (New York), as well as over seventy-five solo exhibitions, and has participated in numerous group shows in the United States and Europe. His works can be found in the permanent collections of the Museum of Modern Art (New York), Solomon R. Guggenheim Museum, Albright-Knox Art Gallery, Detroit Institute of Arts, Los Angeles County Museum of Art, Art Gallery of Ontario, Tate Gallery, Centre National d'Art Contemporain, Stedelijk Museum, and Australian National Gallery, among others.

Five Modular Units, 1970
Steel (painted white),
5′3″ × 5′3½″ × 24′3½″
See page 64

ALEXANDER LIBERMAN

Born Kiev, Russia, 1912

Alexander Liberman emigrated to the United States in 1941. Since 1959 he has been the subject of 50 one-man exhibitions, and his work has been included in approximately 115 group shows at some of the most prestigious cultural institutions in the United States and abroad. In 1977 the artist was given a retrospective at the Storm King Art Center. He was the subject of a film entitled *Alexander Liberman: A Lifetime Burning* and in 1983 was awarded the Henry Moore Grand Prize by the Hakone Open-Air Museum in Japan. His work is included in the collections of forty cultural institutions and corporations, among them the Metropolitan Museum of Art, Museum of Modern Art (New York), Solomon R. Guggenheim Museum, Whitney Museum of American Art, Chase Manhattan Bank, Atlantic Richfield Corporation, Corcoran Gallery of Art, Laumeier International Sculpture Park, and Tate Gallery.

Adam, 1970
Steel (painted orange), 28′6″ × 29′6″ × 24′
Purchase, 1974.29
See pages 52–53

Adonai, 1971
Steel, 35′ × 50′ × 75′
Purchase, 1974.31
See page 55

Iliad, 1974–76
Steel (painted orange), 36′ × 54′7″ × 19′7″
Purchase, 1981.10
See page 54

HENRY MOORE

Born Yorkshire, England, 1898
Died Much Hadham, England, 1986

Henry Moore attended Leeds College of Art and the Royal College of Art in London, then taught for many years at the latter and at the Chelsea School of Art. Greatly influenced by Egyptian, African, and Pre-Columbian monumental sculpture, he has worked in marble, granite, bronze, clay, wood, concrete, and other materials. Moore is also known for his early drawings of coalminers and sketches of people huddled in bomb shelters during the Blitz in World War II. Since his first solo exhibition in London in 1928, the artist has been featured in one-man and group exhibitions throughout the world, and his work is included in the permanent collections of every major museum. He has executed more public and private commissions than any other contemporary sculptor, including works for the Lincoln Center in New York, National Gallery of Art (Washington, D.C.), Unesco Building in Paris, and Hakone Open-Air Museum in Japan. Major retrospectives of Moore's work have been presented at the Metropolitan Museum of Art, Museum of Modern Art (New York), Tate Gallery, Trinity College (Dublin), Orangerie, and the National Museum of Art (Tokyo), as well as in England, Germany, and Italy.

Reclining Connected Forms, 1969
Bronze (green patina), 38″ × 87¾″ × 52″
Purchase, 1971.22
See page 62

ROBERT MURRAY

Born Vancouver, British Columbia, 1938

Robert Murray studied at the School of Art and the Artists' Workshop (1956–60) in Saskatchewan, before moving to New York City in 1960. From 1965 to 1969 he taught at Hunter College and was artist-in-residence at Yale University, University of Oklahoma, and Nova Scotia College of Art and Design. He began an extended teaching career at the School of Visual Arts in New York in 1971. Since his first solo exhibition at the Betty Parsons Gallery, New York, in 1965, Murray has been featured in over twenty one-man shows in the United States and Canada and has participated in many group exhibitions at such institutions as the Whitney Museum of American Art, Solomon R. Guggenheim Museum, Walker Art Center, National Gallery of Canada, Montreal Museum of Fine Arts, Expo '67, and the 1969 São Paulo Bienal (in which he won second prize), as well as in Belgium, England, France, Switzerland, and Argentina. His work is also included in the permanent collections of the Whitney Museum, Metropolitan Museum of Art, Departments of External Affairs and National Defense (Ottawa), National Gallery of Canada, Vancouver International Airport, and many more.

Kiana, 1978
Aluminum (painted sienna), 71″ × 47″ × 86″
Purchased with the aid of funds from the National Endowment for the Arts, 1979.8
See page 93

FORREST MYERS

Born Long Beach, California, 1941

Forrest Myers studied at the San Francisco Art Institute and later taught there as well as at the School of Visual Arts and Kent State University. He was a member of the design team for Expo '70 in Japan. Myers's sculpture has been exhibited at the Whitney Museum of American Art, Jewish Museum, and Los Angeles County Museum of Art, and is included in the permanent collections of the Whitney Museum, Hirshhorn Museum and Sculpture Garden, and Walker Art Center, among others.

Mantis, 1968–70
Cor-ten and stainless steel,
99⅝″ × 120″ × 120″
Purchase, 1970.12

Four Corners, 1969–70
Brass, stainless steel, Cor-ten steel, and
concrete, 120″ × 120″ × 120″
Purchase, 1972.9
See page 79

LOUISE NEVELSON

Born Kiev, Russia, 1900
Died New York City, New York, 1988

Louise Nevelson emigrated with her family
to the United States in 1905. After study-
ing with Kenneth Hayes Miller at the Art
Students League in New York (1929) and
with Hans Hofmann in Munich (1930), she
participated in *Young Sculptors*, a group
exhibition at the Brooklyn Museum in 1935.
After her first one-woman show at the
Nierendorf Gallery, New York, in 1941, her
sculpture was featured in approximately
one hundred solo shows, including a special
installation at the Storm King Art Center
in 1984, and she participated in innumerable
group exhibitions. Her work is included in
the permanent collections of over sixty mu-
seums and galleries throughout the United
States and abroad, including the Whitney
Museum of American Art, Brooklyn Mu-
seum, Metropolitan Museum of Art, Mu-
seum of Modern Art (New York), Princeton
University, Juilliard School of Music, the
City of New York, Massachusetts Institute
of Technology, Los Angeles County Mu-
seum of Art, Museum of Contemporary
Art (Los Angeles), and the Israel Museum.
She received over twenty commissions for
public works of art, and in 1978 the Louise
Nevelson Plaza was created in the financial
district of New York City. In 1983 she re-
ceived the Gold Medal for Sculpture from
the American Academy and Institute of
Arts and Letters.

City on the High Mountain, 1983
Cor-ten steel (painted black),
20′6″ × 23′ × 13′6″
Purchase, 1984.4
See page 60

ISAMU NOGUCHI

Born Los Angeles, California, 1904
Died New York City, New York, 1988

In 1906 Noguchi's family moved to Japan,
where he attended elementary school and
served as a cabinetmaker's apprentice be-
fore returning to America in 1918. After
completing high school and apprenticing
to sculptor Gutzon Borglum, Noguchi
attended Columbia University Medical
School and the Leonardo da Vinci Art
School, which gave him his first solo exhi-
bition in 1924. Three years later he was
awarded a Guggenheim Fellowship and
traveled to Paris, where he studied at the
Académie de la Grande Chaumière and
worked as an assistant to Constantin
Brancusi. Noguchi's works have been fea-
tured in over forty solo exhibitions and
thirty group shows at major museums and
galleries in the United States, England,
France, Germany, Japan, Switzerland, and
the U.S.S.R., including retrospectives by
the Museum of Modern Art (New York,
1947) and Whitney Museum of American
Art (1968). He has designed "total environ-
ments" in the form of gardens in both the
United States and abroad, including com-
missions for the Unesco Building in Paris,
Chase Manhattan Bank in New York, and
the Israel Museum in Jerusalem. Noguchi's
works are included in the permanent col-
lections of the Solomon R. Guggenheim
Museum, Metropolitan Museum of Art,
Whitney Museum of American Art, Mu-
seum of Modern Art (New York), Hirsh-
horn Museum and Sculpture Garden, and
National Gallery of Art (Washington, D.C.),
among many others. He has been the recip-
ient of several awards and honors, includ-
ing the New York Architectural League
Gold Medal (1965), an honorary Doctorate
of Fine Arts from the New School for So-
cial Research (1974), and the Gold Medal
for Sculpture from the American Academy
and Institute of Arts and Letters (1977).

Momo Taro, 1977
Granite, 9′ × 35′2″ × 22′8″
Commission, 1978.4
See page 68

ANN NORTON

Born Montgomery, Alabama, 1915
Died West Palm Beach, Florida, 1981

Ann Norton studied at the National Acad-
emy of Design, Art Students League, and
Cooper Union in the mid-1930s, then served
as an apprentice to Alexander Archipenko

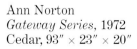

Ann Norton
Gateway Series, 1972
Cedar, 93″ × 23″ × 20″

and John Hovannes. In the 1940s she taught sculpture at the Norton Gallery School of Art, in West Palm Beach, Florida, which was founded by her husband, Ralph H. Norton. A retrospective of Norton's work was held at the Lowe Art Museum in 1981, and her work has also been exhibited at the Museum of Modern Art (New York), Whitney Museum of American Art, the Clocktower, Max Hutchinson Gallery, and other museums in the United States and abroad. Norton's work is represented in the collections of the Detroit Institute of Arts, Los Angeles County Museum of Art, High Museum of Art, and the Musée Rodin, among others.

Gateway Series, 1972
Cedar, 93″ × 23″ × 20″
Purchased with the aid of funds from the National Endowment for the Arts, 1981.2
See page 102

EDUARDO PAOLOZZI

Born Edinburgh, Scotland, 1924

Eduardo Paolozzi was educated at Edinburgh College of Art (1943) and London's Slade School of Art (1944–47). Following a three-year stay in Paris, during which he met and was influenced by Alberto Giacometti, Paul Klee, and various Dadaists and Surrealists, Paolozzi turned his attention, in part, to the academic world. Between 1949 and 1969 he held positions at the Central School of Art and St. Martin's School for Art in London, the Hochschule für Bildende Kunste in Hamburg, University of California at Berkeley, the Royal College of Art in London, and the Fachhochschule in Cologne. In 1947 Paolozzi had his first solo show, and his work has since been featured in more than thirty one-man exhibitions. He has received many awards for his sculpture, which is included in the collections of the Solomon R. Guggenheim Museum, Victoria and Albert Museum, Tate Gallery, National Gallery of Scotland, Museo d'Arte Moderna (Rome), and Museo de Bellas Artes (Caracas), among many others.

Icarus, 1957
Bronze, 56″ × 23″ × 13″
Purchase, 1971.17
See this page

JOEL PERLMAN

Born New York City, New York, 1943

Joel Perlman received his B.F.A. from Cornell University, attended the Central School of Art in London, and earned his M.F.A. in 1967 from the University of California at Berkeley. Perlman then became involved in art education in both England and America and has taught at Bennington College, the School of Visual Arts, and Fordham University. Since 1969 his work has been featured in approximately twenty one-man exhibitions—primarily at the Andre Emmerich Gallery (New York and Zurich) and Roy Boyd Gallery (Chicago and Los Angeles)—and he has also participated in thirty group shows. Perlman is the recipient of Guggenheim and National Endowment for the Arts fellowships, as well as commissions for the Storm King Art Center and for the 1979 Winter Olympics at Lake Placid.

Night Traveler, 1977
Steel (painted black and brown),
10′11″ × 4′3″ × 5′
Purchased with the aid of funds from the National Endowment for the Arts, 1977.1
See page 84

JOSEPH PILLHOFER

Born Vienna, Austria, 1921

Joseph Pillhofer attended the School of Arts and Crafts in Graz, Austria. He later studied under Fritz Wotruba at the Vienna Academy (1947, 1951–54) and was strongly influenced by Constantin Brancusi, Henri Laurens, and Alberto Giacometti, whom he met during his studies in Paris (1950–51). Shown widely in Austrian galleries and museums, especially in Vienna, Pillhofer's sculptures have also been displayed in exhibitions here and abroad. He participated in the Venice Biennales of 1954 and 1956 and was featured in a 1959 retrospective at the Santee Landwar Gallery (Amsterdam). Pillhofer's work is included in the collections of the Museum of Fine Arts, Boston, and National Museum in Tokyo, among others.

Man in the Quarry, 1960
St. Margareten lime-sandstone and gray marble, 101½″ × 37″ × 36″
Purchase, 1961.4

Eduardo Paolozzi
Icarus, 1957
Bronze, 56″ × 23″ × 13″

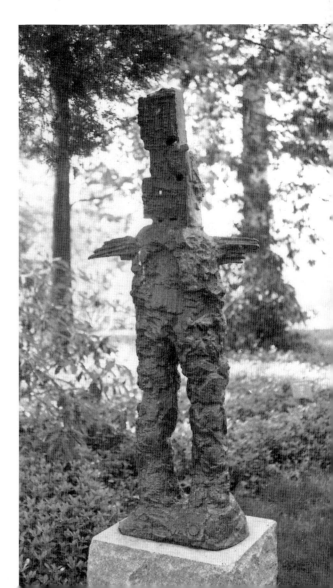

Untitled, c. 1950–60
Marble, 49½″ × 19″
Gift of Mrs. Ralph E. Ogden, 1978.19

Untitled, c. 1950–60
Stone, 91″ × 21″ × 16″
Gift of Joan O. Stern, 1983.1
See page 22

Untitled, c. 1950–60
Stone, 24″ × 14″ × 12″
Gift of Joan O. Stern, 1983.2

Untitled, c. 1950–60
Bronze, 12″ × 47½″ × 15″
Gift of Joan O. Stern, 1983.3

GEORGE RICKEY

Born South Bend, Indiana, 1907

George Rickey moved with his family to Scotland in 1913 and attended Oxford University from 1926 to 1929. He also studied at the Académie André Lhote and with Fernand Léger at the Académie Moderne in Paris (1929–30). After receiving his M.A. from Oxford (1941) and serving in the U.S. Air Force (1941–45), Rickey returned to America, where he studied at New York University, the University of Iowa, and the Institute of Design in Chicago. From 1946 to 1966 he taught at Muhlenberg College, Indiana University, Tulane University, and Rensselaer Polytechnic Institute. Rickey created his first kinetic sculpture in 1945 and began working on larger outdoor sculptures in 1960. Since his first one-man exhibition in 1953 his work has been featured in solo shows in the United States, Amsterdam, Berlin, Munich, and Scotland. Major retrospectives of his work have been presented by the Solomon R. Guggenheim Museum, Maxwell Davidson Gallery (New York), and Corcoran Gallery of Art. Rickey has received an honorary Doctorate of Fine Arts from Knox College, the Skowhegan Medal for Sculpture, and the first Carnegie grant given to an artist.

Six Lines in a T, 1965–79
Stainless steel, 78½″ × 128″ × 30½″
Purchase, 1967.18

Two Planes Vertical-Horizontal II, 1970
Stainless steel, 14′7⅝″ × 10′5″ × 6′3″
Purchase, 1971.12
See page 58

Six Lines Hanging II, 1971–72
Stainless steel, 6′4¼″ × 7′7¼″ × 6′4¼″
Gift of Joan O. Stern, 1983.4

MIA WESTERLUND ROOSEN

Born New York City, New York, 1942

Mia Westerlund Roosen participated in her first group exhibition in 1970 at the Aggregation Gallery in Toronto and was given her first one-woman exhibition a year later at the Albert Campbell Library in Scarborough, Ontario. Since that time her work has been the subject of approximately twenty solo exhibitions and over thirty group shows. Among the galleries that have hosted Westerlund Roosen's one-woman exhibitions have been the Leo Castelli and Zabriskie galleries in New York, Sable-Castelli Gallery in Toronto, and Vancouver Art Gallery. Her sculpture is included in the permanent collections of the Yale University Art Gallery, Art Gallery of Ontario, National Gallery of Canada, and Vancouver Art Gallery.

Muro Series X, 1979
Black-pigmented concrete and steel plate, 60″ × 120″ × 40″
Commissioned with the aid of funds from the National Endowment for the Arts, 1979.1
See page 94

CHARLES SIMONDS

Born New York City, New York, 1945

Charles Simonds attended the University of California at Berkeley (B.A., 1963–67) before earning his M.F.A. at Rutgers University in 1969. He made his public art debut in the early 1970s in both group and one-man exhibitions. In his numerous solo shows since 1975, his art has been featured at the Centre National d'Art Contemporain, Museum of Modern Art (New York), Solomon R. Guggenheim Museum, Leo Castelli Gallery, Museum of Contemporary Art (Chicago), as well as in Berlin, Bonn, Genoa, and others. Simond's work has also been displayed in group exhibitions in New York, Washington, D.C., Minneapolis, Berlin, Bordeaux, Dublin, London, Otterlo, Vancouver, and Zurich. His sculpture is included in the permanent collections of the Museum of Modern Art (New York), Whitney Museum of American Art, Walker Art Center, Museum of Contemporary Art (Chicago), Centre Georges Pompidou, Israel Museum, and Kunsthaus Zurich, among others.

Dwellings, 1981
Clay (two parts), 9½″ × 13″ × 9″; 13″ × 22½″ × 9″
Commissioned with the aid of funds from the National Endowment for the Arts, 1981.3
See page 67

DAVID SMITH

Born Decatur, Indiana, 1906
Died Bennington, Vermont, 1965

From 1924 to 1932 David Smith studied at Ohio University, Notre Dame, George Washington University, and the Art Students League. He began creating sculpture in 1932 and in 1938 was given his first one-man exhibition at Marian Willard's East River Gallery in New York. In 1948 Smith began teaching at Sarah Lawrence College and during 1953–55 was a visiting professor at the universities of Arkansas, Indiana, and Mississippi. In 1950 he received a Guggenheim Fellowship. Smith's sculpture, paintings, and drawings have been the subject of nearly eighty individual shows and have been included in innumerable group exhibitions. While in Italy for a month in 1962 the artist created twenty-seven sculptures known as the Voltri series for the Festival of Two Worlds at Spoleto. Smith was honored with major retrospectives at the National Gallery of Art and the Hirshhorn Museum and Sculpture Garden, both in Washington, D.C., in 1982–83. His work is included in the permanent collections of major museums throughout the world.

Sitting Printer, 1954
Bronze (green patina), 87¼″ × 15¾″ × 16″
Gift of The Ralph E. Ogden Foundation, 1967.9
See page 24

The Iron Woman, 1954–56
Steel, 88″ × 14½″ × 16″
Gift of The Ralph E. Ogden Foundation, 1967.5
See page 29

Five Units Equal, 1956
Steel (painted green), 73¼″ × 16¼″ × 14¼″
Gift of The Ralph E. Ogden Foundation,
1967.4
See page 37

Personage of May, 1957
Bronze (green patina), 71⅝″ × 32″ × 19″
Gift of The Ralph E. Ogden Foundation,
1967.6
See page 27

Portrait of a Lady Painter, 1957
Bronze (green patina), 63⅝″ × 59¾″ × 12½″
Gift of The Ralph E. Ogden Foundation,
1967.7
See page 31

Albany I, 1959
Steel (painted black), 24¾″ × 25¼″ × 7¼″
Gift of The Ralph E. Ogden Foundation,
1967.1
See page 37

XI Books III Apples, 1959
Stainless steel, 94″ × 31¼″ × 13¼″
Gift of The Ralph E. Ogden Foundation,
1967.3
See page 33

Raven V, 1959
Steel and stainless steel, 58″ × 55″ × 9½″
Gift of The Ralph E. Ogden Foundation,
1967.8
See page 40

Study in Arcs, 1959
Steel (painted pink), 132″ × 115½″ × 41½″
Gift of The Ralph E. Ogden Foundation,
1967.10
See page 38

Tanktotem VII, 1960
Steel (painted dark blue and white),
84″ × 36½″ × 14¼″
Gift of The Ralph E. Ogden Foundation,
1967.11
See page 30

Three Ovals Soar, 1960
Stainless steel, 11′3½″ × 33″ × 23″
Gift of The Ralph E. Ogden Foundation,
1967.12
See page 34

Volton XX, 1963
Steel, 62¼″ × 37½″ × 26½″
Gift of The Ralph E. Ogden Foundation,
1967.13
See page 36

Becca, 1964
Steel, 78″ × 47½″ × 23½″
Gift of The Ralph E. Ogden Foundation,
1967.2
See page 41

Becca, 1965
Stainless steel, 113¼″ × 123″ × 30½″
Lent by The Metropolitan Museum of
Art; Bequest of Adelaide Milton de Groot,
by exchange, 1972
See page 73

KENNETH SNELSON

Born Pendleton, Oregon, 1927

Kenneth Snelson studied engineering at
the University of Oregon and Oregon State
University before attending Black Moun-
tain College in North Carolina, where he
worked with Josef Albers, Buckminster
Fuller, and Willem de Kooning. He also at-
tended the Institute of Design in Chicago
and the Atelier Fernand Léger in Paris.
Since his first one-man show at Pratt Insti-
tute in 1963, Snelson's works have been
featured in over twenty-five solo exhibi-
tions and twenty-five group shows in the
United States and Europe, including Eng-
land, France, Holland, and Spain. He has
been the recipient of several awards and
honors, including the New York State
Council on the Arts Sculpture Award, the
Reynolds Metal Sculpture Award, and the
American Institute of Architects' Medal.
Snelson's sculpture is included in the per-
manent collections of the Metropolitan Mu-
seum of Art, Museum of Modern Art (New
York), Whitney Museum of American Art,
New York Stock Exchange, Port Authority
of New York and New Jersey, Hirshhorn
Museum and Sculpture Garden, National
Institute of Health, Art Institute of Chi-
cago, Carnegie Institute, Atlantic Rich-
field Corporation, the cities of Hamburg
and Hanover in Germany, Japan Iron and
Steel Foundation, and the Kröller-Müller
Museum.

Free Ride Home, 1974
Aluminum and stainless steel,
30′ × 60′ × 60′
Purchase, 1975.64
See page 78

RICHARD STANKIEWICZ

Born Philadelphia, Pennsylvania, 1922
Died New York City, New York, 1983

Richard Stankiewicz was raised in Detroit
and served in the U.S. Navy from 1941 to
1947, during which time he began painting
and created his first sculpture. He at-
tended the Hans Hofmann School of Fine
Arts (1948–49) as well as the Atelier Fer-
nand Léger and Atelier Ossip Zadkine
(1950–51). In 1952 he helped form the co-
operative Hansa Gallery in New York.
From 1967 to 1982 Stankiewicz taught
art at the State University of New York,
Albany. Following his first one-man exhi-
bition in 1953 the artist was featured in
more than twenty-five solo exhibitions and
twenty-three group shows in the United
States as well as Paris, Sydney, Stockholm,
Amsterdam, and Belgrade. His works are
included in the permanent collections of
the Museum of Modern Art (New York),
Whitney Museum of American Art, Solo-
mon R. Guggenheim Museum, Hirshhorn
Museum and Sculpture Garden, Walker
Art Center, Art Institute of Chicago, Mod-
erna Museet (Stockholm), Tel Aviv Mu-
seum, and the Centre Georges Pompidou.
In 1984 the Zabriskie Gallery in New
York, which had previously hosted several
of his one-man shows, presented a thirty-
year retrospective of Stankiewicz's work.

Australia No. 9, 1969
Steel, 89″ × 36″ × 48″
Purchased with the aid of funds from the
National Endowment for the Arts, 1975.5
See page 56

DAVID STOLTZ

Born in Brooklyn, New York, 1943

David Stoltz studied sculpture and drawing
under John Hovannes and José de Creeft
at the Art Students League and attended
the Skowhegan School of Painting and
Sculpture on a William Zorach Scholarship
(1963–65). From 1964 to 1966 he also stud-
ied etching and lithography at Pratt Cen-
ter for Contemporary Graphics and served
as an apprentice to William Zorach. In 1968
the Rye Art Center in New York hosted
Stoltz's first one-man exhibition, which was
followed by others in Boston, Chicago, and

New York City. Stoltz has lectured at many educational and cultural facilities, and his works are included in the approximately fifty private and public collections, including those of the Detroit Institute of Arts, Philip Morris, Australian National Gallery, and Louisiana Museum of Modern Art (Denmark).

Day Game, 1972
Steel, 6′7″ × 29′ × 5′6″
Purchase, 1973.2.1

Owo, 1972
Welded steel, 46″ × 78″ × 52″
Purchase, 1972.11

River Run, 1972
Mild steel, 42″ × 26″ × 77″
Purchase, 1972.13

TAL STREETER

Born Oklahoma City, Oklahoma, 1934

Tal Streeter received his B.F.A. from the University of Kansas in 1956. Following three years as a commissioned officer and instructor of cinematography at the Army Signal Corps School, he returned to Kansas to teach at the university and complete his M.F.A. degree in 1961. Since his first one-man show at the Argus Gallery in New Jersey in 1962, Streeter has been the subject of solo exhibitions in the United States, Canada, Japan, and Korea and has participated in many group shows. He has taught at the State University of New York at Purchase, Dartmouth College, and in Japan and Korea. Streeter's work is included in the collections of the Museum of Modern Art (New York), National Museum of American Art, San Francisco Museum of Art, and High Museum of Art, among others. He has also received commissions for large-scale sculptures from a number of institutions, including Mobil International (New York), the state of Nebraska, Art Park (Lewiston, New York), Neuberger Museum, and Corcoran Gallery of Art.

Endless Column, 1968
Steel (painted red), 62′7″ × 6′ × 7′¼″
Purchased with the aid of funds from the National Endowment for the Arts, 1977.2
See page 85

GEORGE SUGARMAN

Born New York City, New York, 1912

George Sugarman received his B.A. from the City College of New York in 1938; he later studied in Paris at the Zadkine School of Sculpture (1955–56). Since 1960 he has been an instructor at Hunter College Graduate School in New York and has also taught at the Yale University Graduate School of Art (1967–68). Sugarman has had over twenty-five solo shows and participated in numerous group exhibitions in the United States and abroad. His sculptures have been commissioned by the Ciba-Geigy Chemical Corp., Xerox Data Systems, the City of Leverkusen, West Germany, the Brussels World Trade Center, and others. His sculptures can be seen in numerous collections, including the Metropolitan Museum of Art, Museum of Modern Art (New York), New York University, Massachusetts Institute of Technology, Singer Co., and Museum Schloss (Marberg).

One, 1975–77
Aluminum with enamel paint,
78″ × 84″ × 72″
Purchased with the aid of funds from the National Endowment for the Arts, 1982.1
See page 94

MICHAEL TODD

Born Omaha, Nebraska, 1935

Michael Todd attended the University of Notre Dame before receiving his master's degree from the University of California, Los Angeles, in 1959. In that same year he was awarded a Woodrow Wilson Fellowship and in 1961 was a Fulbright Fellow in France. While continuing his own sculptural work, Todd was also an instructor at Bennington College (1966–68) and an assistant professor at the University of California, San Diego. His work has been exhibited in France as well as in the United States and is included in the permanent collections of the Whitney Museum of American Art, Hirshhorn Museum and Sculpture Garden, and Los Angeles County Museum of Art, among others.

Parenthetical Zero, 1970–71
Steel (painted brown), 84″ × 96″ × 84″

Purchase, 1972.12
See page 82

ERNEST TROVA

Born St. Louis, Missouri, 1927

A self-trained painter and sculptor, Ernest Trova first exhibited his work at the St. Louis Annual (1947–61). Since then he has been the subject of one-man exhibitions at the Pace and Harcus-Kracow galleries in New York, Fundación Eugenio Mendoza in Caracas, Israel Museum, Hanover Gallery in London, and Dunkelman Gallery in Toronto and has participated in group shows at the Museum of Modern Art (New York), Whitney Museum of American Art, Walker Art Center, and Art Institute of Chicago, among others. His work is included in the permanent collections of the Museum of Modern Art (New York), Metropolitan Museum of Art, New York University, Whitney Museum of American Art, Rhode Island School of Design, Museum of Fine Arts (Houston), Los Angeles County Museum of Art, the City of St. Louis, and Tate Gallery.

Gox No. 4, 1975
Stainless steel, 108″ × 80″ × 108″
Purchased with the aid of funds from the National Endowment for the Arts, 1977.3
See page 83

WILLIAM TUCKER

Born Cairo, Egypt, 1935

William Tucker was educated at Oxford University (1955–58) as well as St. Martin's School of Art and the Central School of Art and Design in London. Since his first solo exhibition in London in 1962 he has been the subject of approximately thirty one-man shows and participated in numerous group exhibitions. His one-man exhibitions have been hosted by galleries not only in London, but also in New York, Los Angeles, Canada, Venice, Rome, Germany, and Australia. Tucker's sculpture is included in the permanent collections of the Museum of Modern Art (New York), Solomon R. Guggenheim Museum, Metropolitan Museum of Art, Walker Art Center, Tate Gallery, British Museum, Arts Council of

Great Britain, Victoria and Albert Museum, and Louisiana Museum of Art (Denmark). He has also been a professor of sculpture at the University of Western Ontario and the Nova Scotia College of Art and has taught at Columbia University and the New York Studio School of Painting and Sculpture. In 1980 he was the recipient of a Guggenheim Fellowship.

Six Cylinders, 1968
Steel (painted dark brown),
55″ × 94″ × 58½″
Purchase, 1969.20
See page 56

DAVID VON SCHLEGELL

Born St. Louis, Missouri, 1920
Died New Haven, Connecticut, 1992

David von Schlegell worked as an engineer for Douglas Aircraft (1942–43) and in an architectural firm (1944–45) before studying painting at the Art Students League of New York with his father, William von Schlegell. After devoting several years to painting, David von Schlegell turned exclusively to sculpture in 1961, working first in wood, then in aluminum and stainless steel. From 1963 through 1983 he was featured in nineteen one-man exhibitions and participated in approximately forty group shows. His work has been commissioned by I. M. Pei for the India Wharf in Boston, the City of Baltimore, NASA, Tulsa International Airport, Capitol Mall (Sacramento), Storm King Art Center, and Saudi Arabian Royal Army Headquarters. Von Schlegell has also received several awards and honors, including the Whitney Annual Award, a Purchase Prize Award from Carnegie International, a Guggenheim Fellowship, and the Skowhegan Medal for Sculpture. From 1971 to 1991 he taught the master's class in sculpture at Yale University Art School.

Untitled, 1969
Stainless steel, vertical element:
96¼″ × 116″ × 13¼″;
horizontal element: 5′4″ × 81′ × 4′4″
Purchase, 1969.11
See page 86

Untitled, 1969
Stainless steel and aluminum,

10′ × 16′ × 14′9½″
Gift of Mrs. Margaret H. Ogden, 1979.6

Untitled, 1972
Aluminum and stainless steel, three elements, 20′ × 304′ × 16′ overall
Commission, 1972.3
See page 86

Two Circles, 1972
Aluminum and stainless steel, two elements, 18′ × 24′ × 18′
Purchase, 1973.5

GERALD WALBURG

Born Berkeley, California, 1936

Gerald Walburg received his B.A. at San Francisco State College in 1965 and his M.A. at the University of California two years later. He also studied at the California College of Arts and Crafts and was an associate professor of art at California State University from 1968 to 1980. Walburg has received recognition for his ceramics and watercolors, as well as for his large steel sculptures. He has had solo shows at Sacramento City College, the San Francisco Museum of Modern Art, and the Royal Marks Gallery in New York and has also participated in several group shows. His works are in the collections of the San Francisco Museum of Modern Art, Oakland Museum, Stanford University Museum of Art, and the City of San Francisco.

Column, 1967
Cor-ten steel, 25′ × 5′ × 5′
Purchase, 1972.14

Loops V, 1971–72
Cor-ten steel, 4′7″ × 16′7″ × 9′5″
Purchase, 1973.3.1
See page 90

ISAAC WITKIN

Born Johannesburg, South Africa, 1936

Isaac Witkin moved to England in 1956 and studied with Anthony Caro at St. Martin's School of Art (1957–60). From 1961 to 1963 he was an assistant to Henry Moore, before assuming teaching duties at Maidstone College of Art, St. Martin's, and Ravensbourne School of Art. From 1965 to 1979 he was artist-in-residence at Benning-

ton College, and in 1975 (when he became an American citizen) also began teaching at Parsons School of Design. Since 1963 Witkin has had several solo exhibitions, including a 1971 retrospective at Bennington, and since 1959 has participated in many group shows. He has received commissions for the City of Springfield, Massachusetts, G.S.A. Social Security Building in Baltimore, and I.N.A. Building in Wilmington. He has been included in two films on art, and in 1981 he received a Guggenheim Fellowship. Witkin's work is represented in the permanent collections of the Hirshhorn Museum and Sculpture Garden, National Museum of American Art, Chase Manhattan Bank, Massachusetts Institute of Technology, and Tate Gallery, among others.

Shogun, 1968
Cor-ten steel, 75″ × 132″ × 120″
Purchase, 1969.9

Masai, 1969
Steel (painted red),
4′1¾″ × 12′11½″ × 3′5″
Purchase, 1969.10

Reunion, 1969
Steel, 22″ × 48½″ × 12″
Gift of Joan O. Stern, 1983.5

Kumo, 1971
Cor-ten steel, 16′3″ × 13′4″ × 12′2″
Purchase, 1971.3
See page 57

Birth of Aphrodite, 1977–78
Steel, 82″ × 180″ × 144″
Purchased with the aid of funds from the National Endowment for the Arts, 1978.1

FRITZ WOTRUBA

Born Vienna, Austria, 1907
Died Vienna, Austria, 1975

Wotruba studied engraving at Vienna's School of Fine Arts and sculpture with Steinhof at the School of Anton Hanak. In the early 1930s he was associated with architect Josef Hoffmann and later in the decade with French sculptor Aristide Maillol in Paris. Returning to Vienna in 1945, Wotruba began his career as a teacher in the Vienna Academy and became an increasingly important force in Austrian art. Since his works were first shown in

Germany in 1931, Wotruba's bronze, marble, and stone sculptures have been exhibited throughout Europe and the United States. Since 1948 he has represented Austria in five Venice Biennales and he also participated in Documenta II in Kassel, Germany (1959). A major retrospective of the artist's work—including drawings, lithographs, etchings, costume and stage designs, and the architectural design for the Georgenberg Church in Vienna-Mauer —was mounted in 1977 by the Smithsonian Institution Traveling Exhibition Service at the Phillips Collection in Washington, D.C.

Man Walking, 1952
Bronze, 58½″ (including 1″ base) × 19″ × 24½″; base (cast as part of the piece): 1″ × 17¾″ × 24¼″
Purchase, 1963.38
See page 23

EXHIBITIONS

David Smith, May 12–October 31, 1976, 14-page checklist.

Alexander Liberman, May 18–October 31, 1977, 12-page illustrated catalog.

Sculpture: A Study in Materials, May 17–October 30, 1978, 24-page illustrated catalog.

Drawings and Sculptures: Noguchi, Calder, and Smith, May 23–October 29, 1979.

Charles Ginnever, May 12–October 31, 1980, 8-page illustrated catalog.

Mia Westerlund and Douglas Abdell: Sculpture and Drawings, May 12–October 31, 1980.

Anthony Caro, May 20–October 31, 1981, 14-page illustrated catalog.

David Smith: Drawings for Sculpture, May 19–October 31, 1982, 48-page illustrated catalog.

Barbara Hepworth, June 12–October 31, 1982, 14-page illustrated catalog.

Henry Moore, May 18–October 31, 1983, checklist.

Recent Acquisitions, May 18–October 31, 1983.

Twentieth-Century Sculpture: Selections from the Metropolitan Museum of Art, May 19–October 31, 1984, 10-page illustrated catalog.

Louise Nevelson: Outdoor Sculptures, 1971–1983, June 30–October 31, 1984, checklist.

Mark di Suvero: Twenty-five Years of Sculpture and Drawings, May 18–October 31, 1985, 18-page illustrated catalog.

Twenty-nine Sculptures from the Howard and Jean Lipman Collection, May 21–October 31, 1986, 12-page illustrated catalog.

The Reemergent Figure: Seven Sculptors at Storm King Art Center, May 20–October 31, 1987, 14-page illustrated catalog.

William Tucker: The American Decade 1978–88, May 23–October 31, 1988, 14-page illustrated catalog.

Wandering into Memory: Sculpture by Anne and Patrick Poirier, May 22–October 31, 1989, 18-page illustrated catalog.

Complex Visions: Sculpture and Drawings by Alice Aycock, May 21–October 31, 1990, 48-page illustrated catalog.

Enclosures and Encounters: Architectural Aspects of Recent Sculpture, May 20–October 31, 1991, 40-page illustrated catalog.

Ursula von Rydingsvard: Sculpture, May 18–October 31, 1992, 40-page illustrated catalog.

Siah Armajani: Recent Work, May 15–October 31, 1993, 6-page illustrated catalog.

Mia Westerlund Roosen: Sculpture and Drawings, May 14–October 31, 1994, 30-page illustrated catalog.

Mark di Suvero, May 13–November 15, 1995; April 1–November 15, 1996, 128-page illustrated catalog.

BIBLIOGRAPHY

Glueck, Grace. "13 Smith Works Find New Home." *New York Times*, March 24, 1967.

"Storm King Art Center: Sculptures by David Smith Attract Attention of Persons Prominent in Art World." *Cornwall Local*, May 11, 1967.

Robbins, Eugenia S. "The Storm King Art Center." *Art in America* 57 (May–June 1969): 108–9.

Robins, Corinne. "Out of the Galleries, into the Fields." *Christian Science Monitor*, October 24, 1973.

Maitland, Leslie. "David Smith Art at Storm King." *New York Times*, May 21, 1976.

Hess, Thomas B. "Smith Alfresco." *New York*, August 9, 1976, pp. 48–50.

Russell, John. "David Smith's Art Is Best Revealed in Natural Settings." *Smithsonian* 7 (March 1977): 68–75.

———. "Art: Sculpture That's King Size." *New York Times*, May 27, 1977.

Hess, Thomas B. "Breakthrough with Tanks." *New York*, June 6, 1977, pp. 70–72.

Ratcliff, Carter. "Alexander Liberman at Storm King." *Art in America* 65 (November–December 1977): 100–101.

Forgey, Benjamin. "Ostracized 'Adam' Is Back, Big and Orange as Ever." *Washington Star*, March 3, 1978.

———. "Storm King—An Extraordinary Collection Pops Out of Nowhere." *Washington Star*, July 29, 1979.

Donadio, Emmie. "Unnatural Appearances: Reflections on Scale at Storm King Mountain." *Arts Magazine* 55 (September 1980): 142–45.

Parks, Addison. "Storm King Visited." *Arts Magazine* 55 (September 1980): 146–49.

Raynor, Vivien. "Sculpture Enhanced by a Dramatic Setting." *New York Times*, August 23, 1981.

Wilkin, Karen. "Caro Sculpture at Storm King." *Museum*, September–October 1981.

Raynor, Vivien. "Hepworths in a Park." *New York Times*, July 4, 1982.

Ashbery, John. "Henry Moore: A Prisoner of His Own Fame?" *Newsweek*, May 23, 1983, pp. 71–72.

Raynor, Vivien. "Art: Henry Moore Sculptures at Storm King." *New York Times*, August 29, 1983.

Brenson, Michael. "Art: 100 Modern Sculptures at Storm King Center." *New York Times*, August 3, 1984.

McGill, Douglas. "At Storm King, Nature Is the Gallery." *New York Times*, May 31, 1985.

Brenson, Michael. "A Sculpture Park for di Suvero's Ladders to the Sky." *New York Times*, August 25, 1985.

Weinberg, Mimi. "Thunder in the Mountains: Mark di Suvero at Storm King Art Center." *Arts Magazine* 60 (February 1986): 38–42.

Heartney, Eleanor. "Nature and Culture." *ArtNews* 74 (October 1986): 11–12.

Brenson, Michael. "Images That Express Essential Human Emotions." *New York Times*, July 26, 1987.

Hughes, Robert. "Gods, Chess and 38,000 Magazines." *Time*, June 13, 1988, pp. 78–79.

Brenson, Michael. "A Sculptor Caught Up in His Materials." *New York Times*, July 12, 1988.

MacLeod, Pamela. "Sculpture: On the Lawn of the Mountain King." *Wall Street Journal*, June 6, 1989.

Larson, Kay. "Inside Out." *New York*, June 15, 1992, pp. 100–101.

Kimmelman, Michael. "Intimations in Wood of Ritual and Refugee Camps." *New York Times*, July 17, 1992.

Phillips, Patricia C. "Ursula von Rydingsvard: Storm King Art Center." *Artforum* 30 (September 1992): 101.

Strauss, David Levi. "Sculpture as Refuge." *Art in America* 81 (February 1993): 88–92, 125.

Zimmer, William. "Order Meets Anarchy in a Show at Storm King." *New York Times*, June 6, 1993.

Taplin, Robert. "Siah Armajani at Storm King." *Public Art Review*, fall/winter 1993, pp. 34–35.

Kimmelman, Michael. "3 Hudson Valley Shows Are Widely Divergent." *New York Times*, July 8, 1994.

Megerian, Maureen. "Le Storm King Art Center: Sculpture moderne dans le paysage." *L'Oeil*, April 1995, pp. 57–60.

Kimmelman, Michael. "Art in Greener Pastures, Outside New York. The Hudson Valley Crop: Portraits and di Suvero." *New York Times*, July 14, 1995.

Turner, Jonathan. "Mark di Suvero: Storm King Art Center." *ArtNews* 94 (October 1995): 147.

DIRECTIONS

From New York City
- Approximately 1½ hours. 65 miles
- George Washington Bridge to Palisades Parkway
- Intersect New York Thruway (Route 87) at Exit 9N
- Follow New York Thruway to Exit 16 at Harriman
- Turn right onto Route 32 North for 10 miles until you reach bridge
- Cross bridge and take immediate left turn onto Orrs Mills Road
- Go 1/2 mile, turn left on Old Pleasant Hill Road
- Main entrance and lower parking lot 1/2 mile on left.

From Lower Westchester
- Take Cross Westchester Expressway (Route 287) to New York Thruway (Route 87), proceed as above.

From Upper Westchester
- Take Route 684 North to Route 84 West
- Cross Newburgh-Beacon Bridge and take first exist (Exit 10)
- Make left turn onto Route 9W South
- Follow Route 9W South to Broadway in Newburgh
- Turn right onto Broadway, then first left turn at traffic light on Route 32 South.
- Follow for 6 miles through Vails Gate and down a hill. Right turn on Orrs Mills Road (Do not cross bridge). Go 1/2 mile and turn left on Old Pleasant Hill Road. Main entrance and lower parking lot 1/2 mile on left.

From Upstate New York
- New York Thruway south to Exit 17
- Left on route 17K to the center of Newburgh
- Right turn on Route 32 South
- Follow for 6 miles through Vails Gate and down a hill
- Right turn on Orrs Mills Road (Do not cross bridge)
- Go 1/2 mile and turn left on Old Pleasant Hill Road
- Main entrance and lower parking lot 1/2 mile on left.

Storm King Art Center
Old Pleasant Hill Road
Mountainville, New York 10953
(914) 534-3115

INDEX